America

WRIGLEY FIELD'S
AMAZING VENDORS

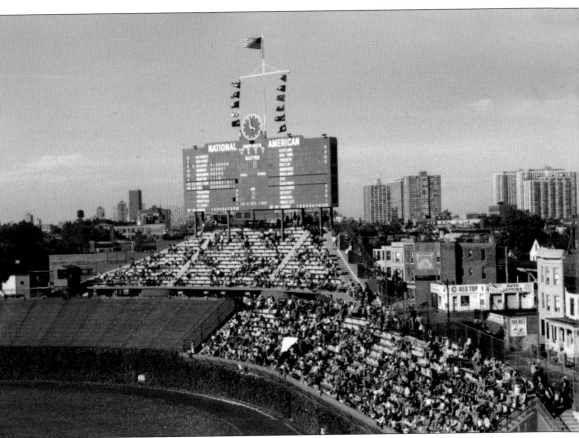

The majestic Wrigley Field scoreboard shows it is almost 4:00 p.m. on a cloudless Sunday afternoon, October 1. There are two outs in the bottom of the ninth inning as the Cubs are about to lose their final game of the 1978 season to the New York Mets by a score of 5-3. The attendance for the game is 11,617, with many of the bleacher faithful waiting for the inevitable final out before hoping for next year, always next year. (Courtesy of Lloyd Rutzky.)

FRONT COVER: In 1975, veteran vendors George Rizzo and Ira Brinkley pause just after the gates have opened at Wrigley. Rizzo is about to get a load of hot dogs to sell, while Brinkley shows his Pro's Pizza carrier. The pizza company was started by former Cubs all-star Ron Santo. (Courtesy of Lloyd Rutzky.)

UPPER BACK COVER: Young hawkers in 1978—Marc Perper, David Shanker, Arlen Korer, Wayne Fisher, Michael Klass, and Ken Dolin—surround Bob Rose, who had been vending for over 30 years. (Courtesy of Lloyd Rutzky.)

LOWER BACK COVER (FROM LEFT TO RIGHT): Harlan Grabowsky exhibits his mammoth load of souvenirs in 1979 (courtesy of Lloyd Rutzky); Art Newman, in his red blazing bathrobe and paper hat, marches with an overfilled tray of pre-poured beer in 1980 (courtesy of Lloyd Rutzky); and Dave Klemp, in the traditional light blue shirt, sells the king of ballpark food—hot dogs—in 1975 (courtesy of Lloyd Rutzky).

Images of Modern America

WRIGLEY FIELD'S AMAZING VENDORS

Lloyd Rutzky and Joel Levin

ARCADIA
PUBLISHING

Published by Arcadia Publishing
Charleston, South Carolina

Printed in the United States of America

Library of Congress Control Number: 2018941673

For all general information, please contact Arcadia Publishing:
Telephone 843-853-2070
Fax 843-853-0044
E-mail sales@arcadiapublishing.com
For customer service and orders:
Toll-Free 1-888-313-2665

Visit us on the Internet at www.arcadiapublishing.com

*This book is dedicated to Irving Newer and all baseball
employees who toil anonymously under the stands
and in the aisles of major-league ballparks.*

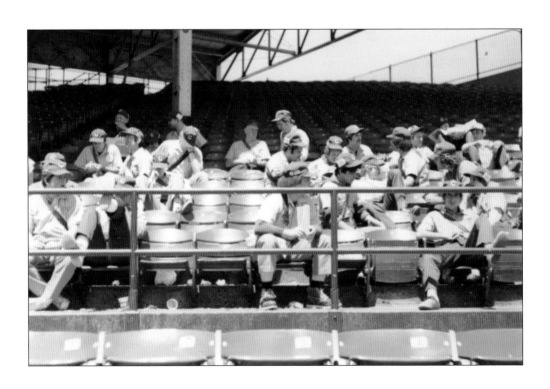

CONTENTS

ACKNOWLEDGMENTS

"Every man for himself" is the way it is when working at the ballpark. But writing a book is another story. I have many people to thank for putting this all together, and I would have to start at the beginning with my dad, Jules Rutzky, who gave me a love of baseball when I was four years old, listening to games on family car trips and at home. Eventually, I became a baseball card collector—and of course dreamed of being a ballplayer—and at the age of 17, I was going to a big league park every day, but not running the bases; I was running with loads of pop trays to sell. Okay, if I was not on the team, at least my case totals were like home run statistics and my daily commission amounts were like a batting average; if I could average $30 a game in 1970, I felt that was like hitting .300.

Once I felt comfortable as a part of the team of ballpark workers, I wanted to take a picture of everybody who worked there. And I just about did, taking over a thousand pictures. Many of my subjects thought I was crazy, wasting time when I should be selling. Others complained I hardly knew them and who would ever care to see their picture? But as the years passed and many of my subjects passed on, those who viewed these images began to see what a treasure they were.

There would not be any treasures, though, without the contribution of my father's older brother, Harry Rutzky. When I transferred to Chicago's Columbia College in the fall of 1968 after three frustrating years at the University of Illinois at Chicago Circle (in 1982 the "Circle" was dropped from its name), I decided I wanted to take a course in photography. To my surprise, during the first class, I was told I needed to have a 35-mm camera to take "proper" pictures. And having only snapped with a cheap one up until then, I needed help in getting the proper equipment. My dad suggested I talk to Uncle Harry because he had a business in retail advertising and might know what I should get. And with my uncle's help, we found a great deal on a used Nikon he knew a friend wanted to sell. It was valued at about $500 but I got it for $50. That is what I used to take all of my pictures at the ballpark.

I would like to thank my cowriting partner Joel Levin, who was my competitor for beer sales many years ago. It was great to team up with him when he thought my pictures would make for a wonderful book. It was his legwork that finally found us a place with Arcadia Publishing. My gratitude also goes to Mike Gold and Fred Homer for several of their pictures.

Furthermore, undying praise for the incomparable assistance of my wife, Helita Rutzky, and my youngest daughter, Liz Forcier, whose expertise with computers enabled Joel and I to coordinate all of these words and pictures into this "amazing" book.

I was also touched by two former vendors who have achieved mightily beyond the ballpark and who sent us fond words. The first is a man who vended with me from 1974 through 1980 and later became a friend and economic adviser to Pres. Barack Obama, John W. Rogers Jr., founder of Ariel Investments:

In 1974, when I was 16 years old, I started my first summer job as a vendor at Wrigley Field. My inspiration was Lloyd Rutzky, who used to sell pizzas at the ballpark to my father and me on Sunday afternoons.

I started at the bottom like everyone else selling Coke. I worked my way up to peanuts, then hot dogs, and finally the ultimate . . . beer! I ended my career as a proud Stroh's vendor at Comiskey and an Old Style vendor at Wrigley. I had reached the peak.

I had the opportunity to meet and work with some extraordinary and wonderful people. I also learned valuable life lessons that remain with me to this day. One of the first lessons was to be strategic. In order to maximize my selling time, I had to carefully plan out my day. I soon realized there was a direct correlation between my hard work and results. As vendors, we were compensated based on productivity. I have so much

respect for the vendors with who I worked, especially those like Lloyd who have devoted over 50 years to their jobs. Every one of them inspired me to do my best work.

The second is a very talented broadcaster and one of the most obsessed Cubs fans I ever met, who vended with me from 1979 to 1984, David Kaplan of ESPN 1000 and NBC Sports Chicago:

> Looking back at my days as a vendor are some of my fondest memories. My brother Bruce and I would drive together, and we would hustle as hard as we could to move as many loads of whatever product we were selling. We both started on soda pop, then we moved up to peanuts. But when we moved up to beer was when we really started to make some good money. We would always try to beat the veteran vendors like Lloyd Rutzky, and it made us chuckle how mad Lloyd would get when we sold more beer than he did. It was a great job and knowing how much my brother and I loved Chicago sports, it was the perfect way to watch games and make great money. Every time I go to one of our stadiums to broadcast a television show, I look at the stands and I am reminded of how much I loved being a vendor.

Joel Levin wishes to thank Mitch Levin, Michael Ginsburg, William Griffin, and Dr. Paul Smulson, who were invaluable for their support and encouragement of *Wrigley Field's Amazing Vendors*. All are current or former vendors. Jeff Reutsche and Stacia Bannerman of Arcadia Publishing deserve recognition for guiding this work from initial concept to published manuscript. The Alumni Association of Northeastern Illinois University provided excellent research facilities and a friendly staff that understands an author's needs.

Joel's daughter Victoria is greatly thanked for hours of technical assistance that insured the manuscript would "play ball." The most special thank-you of all goes to Joel's wife, Peggy. She unhesitatingly traveled to the grave of Martin "Marty Mo" Moshinsky to take the photograph that appears in this book. More importantly, Peggy welcomed Marty Mo into our house for a Christmas dinner not so long ago. We all enjoyed a meal with a legend.

Unless otherwise noted, all images are part of the Lloyd Rutzky collection.

INTRODUCTION

The story of publishing *Wrigley Field's Amazing Vendors* is almost as amazing as the photographs themselves. It involves two Arcadia books, a time span of 14 years, and a set of fortuitous circumstances that will, undoubtedly, enter Chicago vendor history.

In 2004, Arcadia published *Forgotten Chicago* by John Paulett and Ron Gordon in its Images of America series. In black and white photographs and captions, the authors documented the city's forgotten and destroyed rail stations, sports venues, diners, and single-room occupancy hotels. On page 65 was an image of an old man, a vendor, selling peanuts at Comiskey Park, a stadium that too would shortly face the wrecking ball. He was called "The Peanut Man" since the authors never got his name. They described him in this manner: "His was the face of a lifetime of hard work and independence and a million miles of stairs at the old ball park." He could not have looked more forlorn and friendless, in addition to being nameless, in *Forgotten Chicago*.

While researching his personal memoir, Joel Levin, a former ballpark vendor and retired Chicago Public Schools teacher, happened upon a copy of *Forgotten Chicago* at a local used book store. Browsing through the book for interesting tidbits of information, he stumbled upon page 65 and "The Peanut Man." There was instant recognition of the old vendor—he had a name! It was Irving Newer. Levin and Newer were buddies; they had worked together for over 15 years at Wrigley Field and Comiskey Park. In fact, Irving or "Uncle Irv" had been a buddy and mentor to thousands of young vendors during his 40-year vending career. The injustices of the photograph were numerous. Uncle Irv in a book nameless? Irv forgotten? Irv selling *peanuts*? Levin decided that something must be done to bring recognition to his fellow vendor, and he knew just the person to call.

Lloyd Rutzky is a current Chicago beer vendor of renown, having worked over five decades at Cubs and White Sox games. Besides writing movie reviews on a regular basis, Rutzky has another hobby developed during his years at Columbia College—photography. From the start of his ballpark career, Rutzky has used his camera to record the daily activities of his fellow vendors, ushers, commissary workers, security officers, and cashiers during game time. His photographs show the action in the stands, with the baseball game itself being secondary. The main question on Levin's mind when he met Rutzky was whether Rutzky had a photograph of Irving Newer selling Frosty Malts at Wrigley Field. Levin's book idea was one that would honor all the vendors in Chicago so that they would never be nameless again.

By coincidence, both Levin and Rutzky had separately thought of writing a book about Chicago's vendors based upon their experiences at Wrigley Field and Comiskey Park. Both knew and admired Irving Newer, and, yes, Rutzky did have several photographs of Uncle Irv selling Frosty Malts at Wrigley Field. Ideas were exchanged, and a new baseball book, unlike any other, began to take shape. Rutzky's amazing photographs would be the centerpiece of a book that would name and recognize employees who work anonymously under the stands and in the aisles of Chicago's ballparks. The writing of the book would be shared equally if an interested publisher was willing to step up to the plate.

Wrigley Field's Amazing Vendors is organized into four chapters, each with a distinct theme. Chapter one, "Aisles of Opportunity," is cinema verite at its finest. Rutzky's camera captures the vendors in their most relaxed state—eating lunch, reading, smoking, talking, or just monkeying around. Chapter two, "Here Come the Vendors," means "play ball"—go to work. Readers will observe the vendors selling, making change, pouring beer, yelling out their items' names, and competing for sales. In chapter three, "We're a Team," Rutzky documents the many other groups of Wrigley Field employees who work alongside vendors, from cashiers and commissary personnel to ushers and union stewards. They deserve recognition as well. Chapter four, "The Legends," salutes three vendors who were fan favorites, instantly recognizable and liked by everyone they came in contact with. They will always be remembered as the legends of vending. Welcome to the world of *Wrigley Field's Amazing Vendors*.

One

AISLES OF OPPORTUNITY

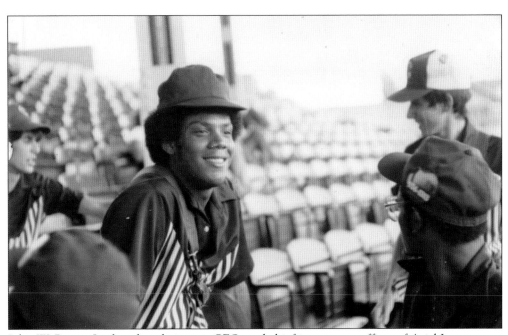

John W. Rogers Jr., founder, chairman, CEO, and chief investment officer of Ariel Investments LLC, stated: "The experience of being a vendor was transformative for me. It was a job I looked forward to every single day because it combined my love of sports, my desire to stay physically active, and my motivation to be an entrepreneur." Rogers is pictured here in August 1978.

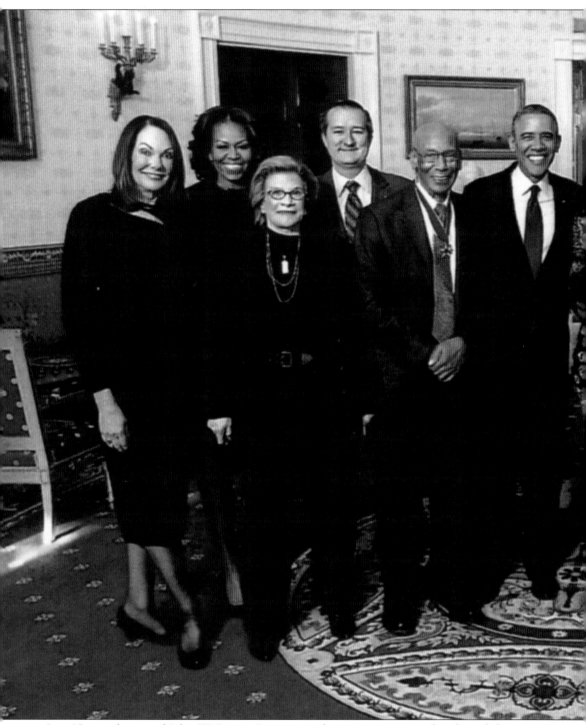

It is 35 years later, and John W. Rogers Jr., seen on the previous page and at far right), is now standing tall—in the White House—with his friend for over 20 years, the 44th president of the United States, Barack Obama, to whom Rogers was an economic adviser. Here, on November 20, 2013, the president is awarding the Presidential Medal of Freedom to baseball hall-of-famer and

Cubs legend Ernie "Mr. Cub" Banks (seen next to the president). Also pictured are Cubs chairman and owner Thomas S. Ricketts (fourth from left), Cubs hall of fame outfielder Billy Williams (fourth from right), and Cubs hall of fame pitcher Ferguson Jenkins (second from right).

Of course these vendors are happy: they are enjoying a Frosty Malt, one of the most popular items ever sold at Wrigley Field, in August 1976. Above is Jim Smith giving a thumbs up, and below is Edward Rubin smiling as he finishes the tasty treat from Borden's Ice Cream Company. What these photographs do not show, however, is the vendor who sold them the Frosty Malts, which undoubtedly would be Irving Newer, "Uncle Irv." Uncle Irv was always the first vendor out of the commissary with a load of these chocolatey cups. He would also sell them to the other vendors as they finished their lunches. The famous "Bleacher Bums" of 1969 would only buy this chilly classic from Uncle Irv. Newer was legally blind during the twilight of his career at "The Friendly Confines."

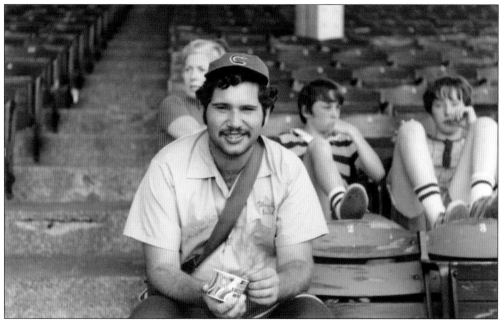

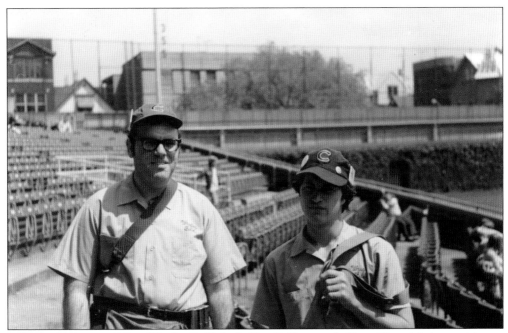

A beautiful day in 1976 at Wrigley Field finds Shia Fefferman (left) and Ross Medow waiting to go to work. Each vendor was required to wear identification badges pinned to their Cubs caps. The reason they have different colored vendor straps (red and green) is simply that they were purchased at different times.

Cubs fans and vendors would casually sit together and talk, as this June 1977 photograph shows. Michael Lovett (left) and Mike Halperin are enjoying the sunshine at Wrigley Field in the lower left field grandstand. Note the vendor two rows up reading the newspaper next to other vendors and fans. Friendships among vendors and fans were common. This was the Friendly Confines in action.

Pictured above in 1975, Phil Grazier idly twiddles his thumbs, but there is another Frosty Malt customer of Uncle Irv sitting below him along the third base line. Vendors would sit in close-knit groups like this and wait for a "critical mass" of fans to arrive before they started working. Individual decisions were then made when to "strap up" that first load. While some went out early, others would wait almost until game time. The 1976 photograph below shows Steve Drexler (first row, left) and Gary Gumbiner (first row, right) in the right field grandstand as the "second unit" waits for that critical mass of Cubs fans to arrive.

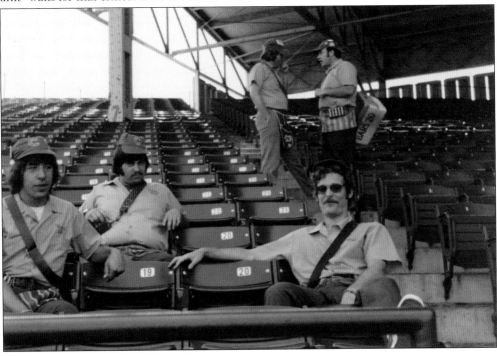

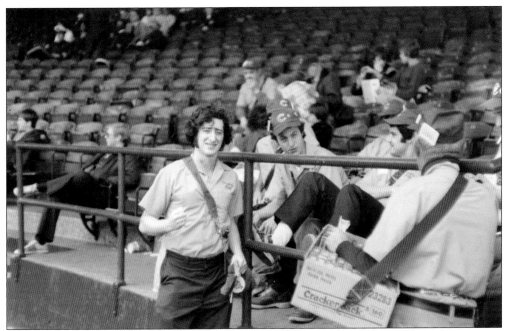

Pregame action abounds in this April 1976 photograph. Cracker Jack-er Hymie Rubin has just grabbed his first load while Lloyd Rutzky is fist-pumping the seated Brandon Medow and Bradley "Flash" Gordon about something or other. And up yonder, a platoon of Andy Frain ushers is receiving their marching orders.

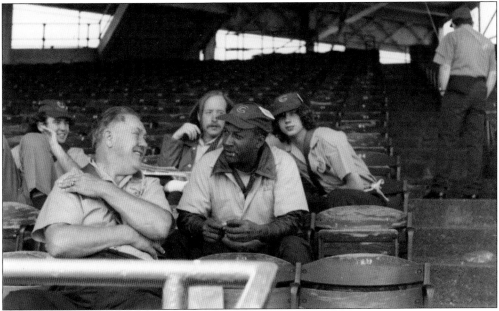

In 1975, older vendors Gene Skonicki (left) and Henry Wakefield powwow about the wild-looking, long-haired younger generation typified by the three lads behind them, (from left to right) Pat McDermott, Dave Klemp, and Eric Eckstrum. The one exception to this rule was Irving Newer. Although definitely one of the oldest working vendors, Irv delighted in mentoring the "youths."

John Kurpiel, nicknamed "Boston Johnny" for unknown reasons, is surveying what appears to be a sparse crowd while an Andy Frain usher looks on in 1975. He is not wearing official Cubbie blue vendor pants, as was required. This is because he was working a souvenir stand, where slight dress code infractions were often overlooked.

Wages earned as a vendor at Wrigley Field and Comiskey Park frequently paid college tuition bills for future lawyers, accountants, teachers, and other professionals. Once secure in their upscale vocations, some would continue to work at the ballparks as a second job. Thus it was for Howard Goldrich, attorney and vendor, pictured here in 1975.

Smiling Randy Kadet (left) and Kenny Dolin, pictured here in July 1977 in the left field grandstand, must be anticipating a large crowd at Wrigley Field. From the way the box seats are filling up, they are probably right.

A sunny but chilly day in May 1976 finds Eddie Butler waiting to take out his first load of beer. The beer opener hanging from his green vending strap is the giveaway as to what item he will be selling. Fans and vendors in long sleeves attest to the fact that May can be a cold month at Wrigley Field on Chicago's lakefront.

Camaraderie and competition go hand in hand in a vendor's world. Pictured here in 1975 are, from left to right, Mark Reiner, Mike Ginsburg, Ron Pollakov, and Gary Shulman shortly before they start working. Once vending, it is the quickest one who gets the sale. After the game, it is "What do you guys want to do tonight?"

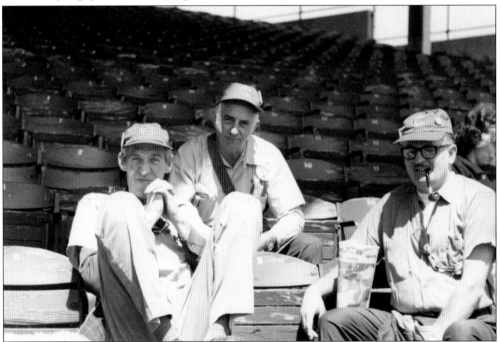

Here are three friends sharing some quiet time before they have to start hustling. From left to right are Fred Richissin, Ted Galuska, and Jimmy Bendas. Smoking was definitely permitted at Wrigley Field in 1976.

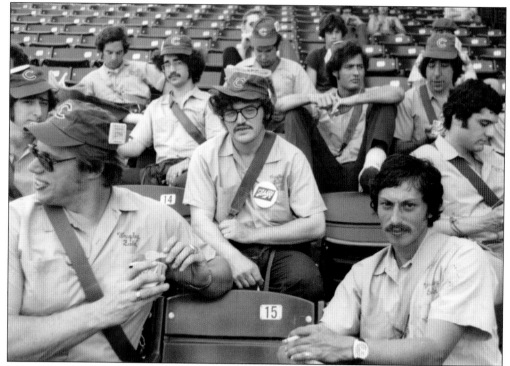

Marv Mitofsky (center), wearing a Schlitz button, appears reluctant to go around the park and "grab for all the gusto he can" (as the Schlitz commercials said). Lloyd Rutzky (next to Mitofsky at left) likewise is not yet ready to be a beerman. Ditto the other recliners here, including Bill Bailen, Maury Rosenblatt, Ken Dolin, Jay Lawrence, Ron Pollakov, and Steve Drexler. (Courtesy of Mike Gold.)

Sometimes the men waited too long for what they considered a large enough crowd to start selling and began acting like little boys. Goofing off in the tradition of Harry Caray's famous line, "you can't beat fun at the old ballpark" in August 1976 are, from left to right, Abe Rapuch, Glenn Smoler, and Art Newman. (Newman is also pictured on the back cover.)

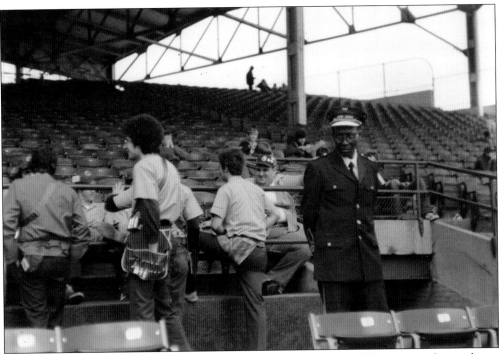

Conversation biggies for the fellas still waiting in the stands for the Wrigley crowd to make its appearance were dominated by "How many?"—as in "How many people do they expect?," "How many other guys are on my item?," and "How many loads can I sell?" This photograph was taken in April 1976.

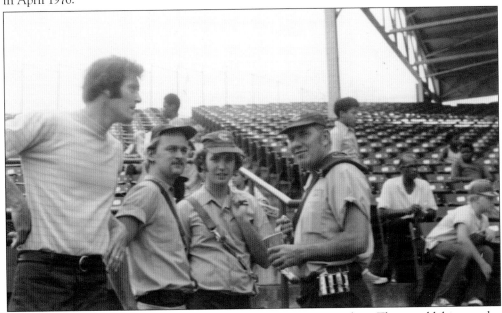

Wendell Schmalz (far left) supervised Wrigley Field's commissary workers. They would drive trucks, deliver supplies, inventory goods, and whatever it took to keep hot dogs hot and cold beer cold. Schmalz is shown here talking to vendors (from left to right) Jim Gwisdala, Patrick McDermott, and Frank Kransnowski in 1975.

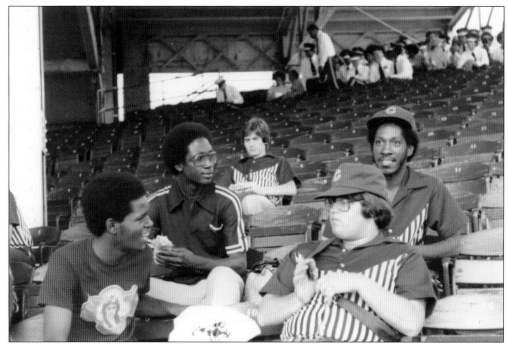

The gates have not yet opened in this photograph from August 9, 1978. The ushers, seated in the top rows, really had no choice as they were expected to be on time—or else. Young vendors, though, like Greg Grant and Greg Kohan (first row) and Ed Thomas and Eric McCoy (second row) arrived early to try to get the better items as they did not have enough seniority yet to be a regular on something good.

"How much for your button?" was a routine proposition vendors would encounter. Cashiers issued them free to employees, but they were supposed to be returned after each game. Sometimes, though, those buttons would accidentally "fall off." David Behm, a future dentist, has two buttons here, and it might be like pulling teeth to get him to lose one. Or would it?

From left to right, Angelo Acvello, George Stanley, and Dennis Cortopasi are putting on their best happy faces here on another typically wintry day in the spring of 1978.

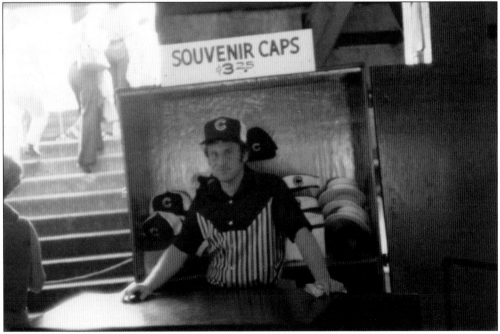

While the stands are still filling up, most vendors are still sitting down in the seats. But if one had a stand, it had to be ready as soon as the gates did open. Paul David Rubin is just such an employee, smiling and waiting for customers he can sell baseball caps to in 1978. The majority of his dry goods are Cubs attire, but at lower right is a New York Mets cap.

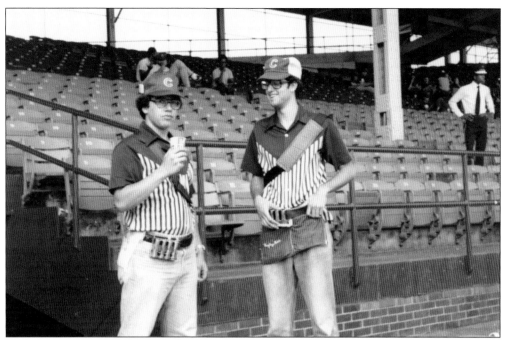

Nickels and dimes—remember those? Bruce Cooper and Larry Goldstein, seen here in 1979, apparently felt it made good "cents" to have changers on their belts, giving them a big advantage when dealing with small change that many of their little customers only had from their allowances.

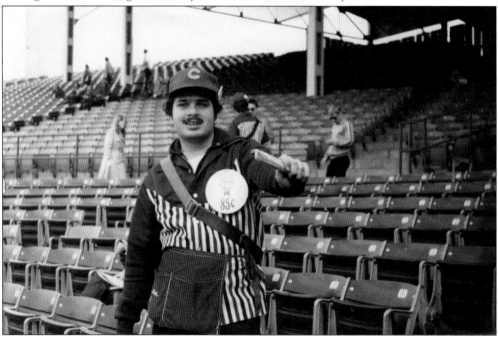

Ray Ullmann, pictured in April 1978, happened to be nicknamed "The Raven." With apologies to poet Edgar Allan Poe, it was no surprise that once upon an afternoon dreary, this vendor pondered weak and weary, and when the camera snapped its shutter, the Raven's arms would flail and flutter. Can't we be friends just like before? Quoth the Raven, "Nevermore."

Wrigley Field vendor Kevin Anderson, wearing a taboo White Sox cap, seemed to take great pleasure in trying management's patience. Meanwhile, Brian Kelly and Tina O'Connell do not have any hats on at all. The life of a supervisor at the ballpark was not easy.

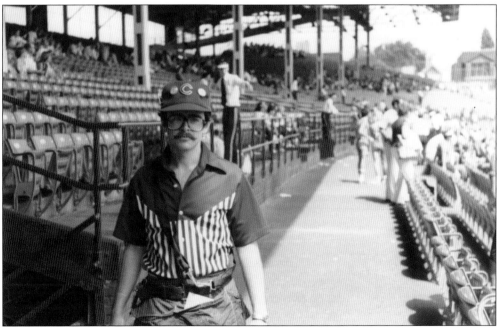

Jim Aten poses before the final game of a Cubs home stand on August 9, 1978. Peeking out from his somewhat dilapidated red apron is his item card. If that card read "Coke" for another "beautiful day at Wrigley," like Ernie Banks used to say, Aten just might invest in a new apron to preserve the nice commissions he was likely to earn.

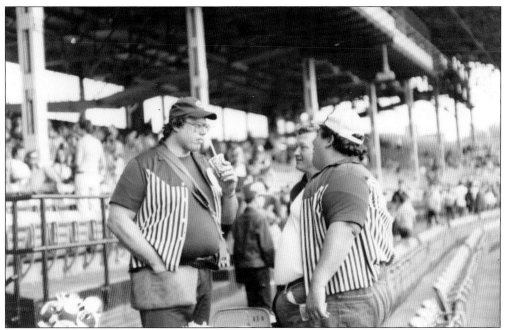

In May 1979, Harlan Grabowsky (right) has just put down his basket of Cubs souvenirs to talk with Bill Bailen (left) and Jim Smith. Souvenirs, also called novelties, were an "X" item, meaning only one vendor would be assigned to sell them for the entire ballpark. Orangeade and lemonade were also X items.

Small crowds were common in April 1979 before schools let out, so Wayne Fisher, pictured here, would probably ask for the premium selling item—hot dogs. But would steward Luke Bajic grant such a request? If Fisher came regularly and had sold "pups" the previous day, his chances were better than the vendors who took days off, which many did for things like college or another job.

The Cubs played the St. Louis Cardinals on June 27, 1980, a game they would eventually lose 3-2 in 12 innings. Beermen Larry Powell (left) and Alan Glass might be sad about the final score, but undoubtedly were delighted that the game went into overtime since it would not be until 1983 that a cutoff time for beer sales was enacted.

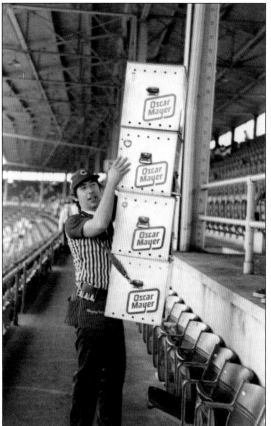

Management and union officials were not blind to vendors' shenanigans. But somehow guys still dared to perform potentially dangerous stunts. Case in point is Steve Drexler monkeying around with an eye-popping quadruple load of wieners. Of course, all these cases were empty—nobody in their right mind would attempt doing this fully loaded.

Two

HERE COME THE VENDORS

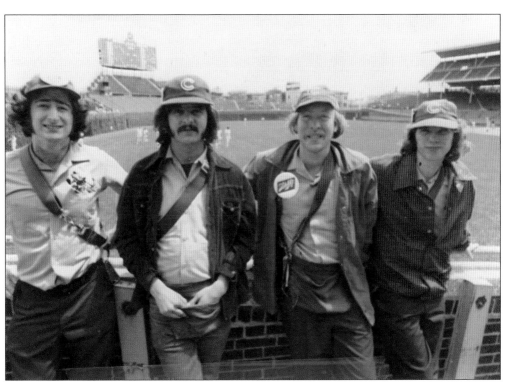

With the gates just opened, these four hustlers line up, looking almost like gunslingers with their iconic vending straps slung fancily over their shoulders and their trusty bottle openers attached. Grinning eagerly as they prepare for a day's work in May 1976 are, from left to right, author Lloyd Rutzky, with his challengers he hopes to outduel in the sun for sales, Abe Rapuch, Dave Klemp, and Eric Eckstrum. (Courtesy of Mike Gold.)

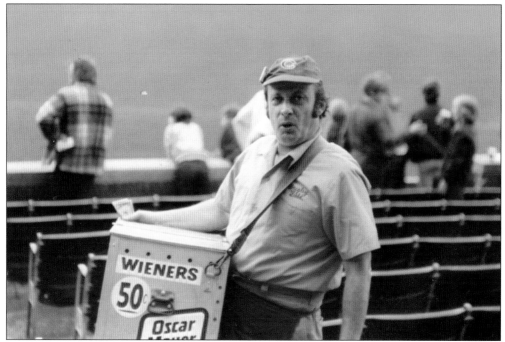

Pictured are two Mike Rubins, both selling Oscar Mayer wieners, also known as hot dogs. Above is Mike Rubin, an original member of the Building Service Employees Union, Local 236, formed in the 1940s. He also was Lloyd Rutzky's uncle and was instrumental in bringing Rutzky into vending by first giving Lloyd's older brother Ron a job at his stand in Comiskey Park's upper deck in 1964, one year before Lloyd signed on. Ron lasted one season, Lloyd has worked over 8,000 games and is still there. Below is a much younger and different Mike Rubin, who later became a union official and is also still there.

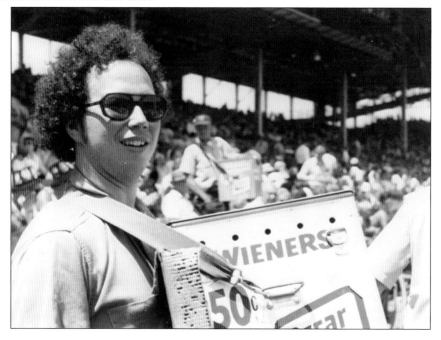

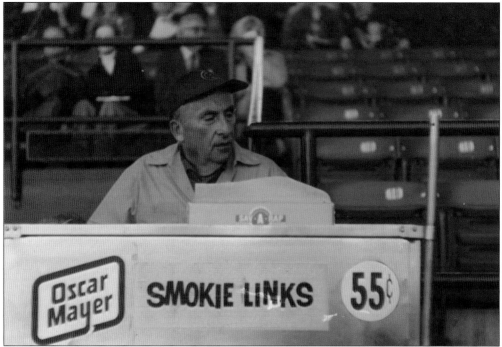

For a nickel more than a hot dog in 1975, one could have a freshly grilled Smokie Link. Fans could either find a "wagon" (also known as a "portable") out in the seating area, stationed on the main aisle between the two lower boxed seat sections and the two upper grandstand sections, or one on the main concourse after entering the park. There were no televisions on that level until the 1990s, so fans preferred the seating area wagons so as to not miss the game. Pictured here are two veteran men who had paid their dues to get this prestigious leg-saving item, Solly Gold (above) and George Levin (below).

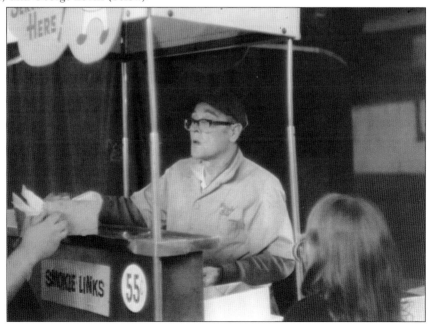

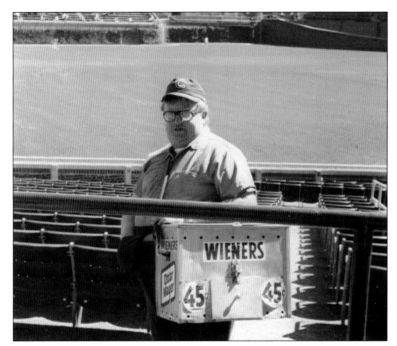

Wonderfully eccentric Johnnie Skweres smilingly poses as a 45¢ hot dog man in 1974, the price a nickel cheaper than 1975. Skweres was noted for doing strange things, among them flying to different cities just so he could say he was there and immediately flying home.

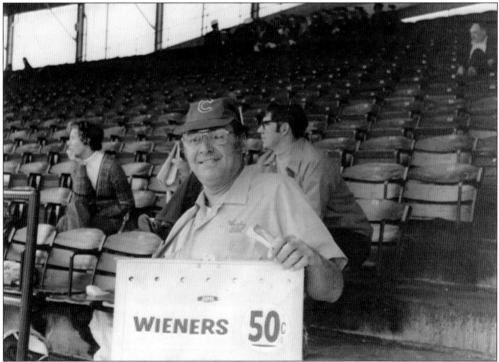

Sam Arkules began working at Wrigley Field as a cashier with a seemingly cushy job, seated all day selling the vendors their load tickets and checking them out after games and totaling their pay. Until the mid-1980s, commissions were paid in cash, daily. As a cashier, Arkules was paid by the hour, but after seeing how much more lucrative it was to be paid by commission, he eventually switched jobs.

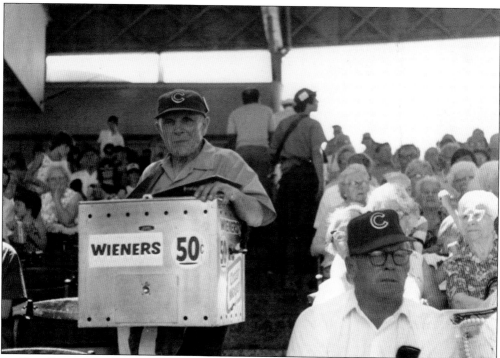

Joe Krozelle was a small guy, his hot dog box seemingly as big as he was, but he was pretty tough—he is seen here vending in his 70s in the 1970s.

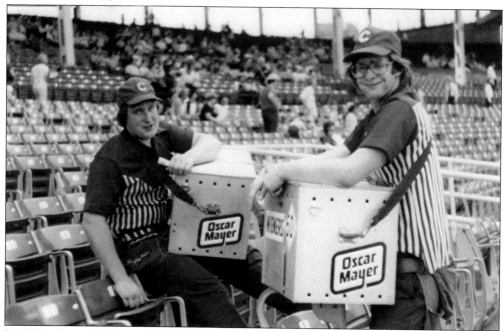

In 1978, the modern era of vending uniforms began, as simple blue shirts with Wrigley Field monogrammed on them were no longer in fashion. Here, hot dog boys Gene Kostka (left) and Norm Kellerman model their red, white, and blue jerseys. However, these uniforms would be in vogue for only two seasons.

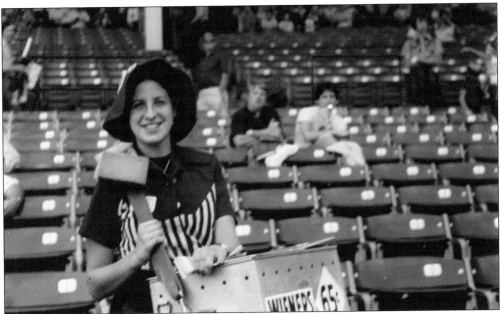

Among the first female vendors was teenager Melinda Korer, popularly nicknamed "Tweety Bird." She found romance among her fellow vendors and married John Studnicka Jr., who sold souvenirs. He was the son of John Studnicka, the union steward across town at Comiskey Park. Her husband would eventually become union steward at Wrigley Field. Dig that crazy hat she was somehow allowed to wear!

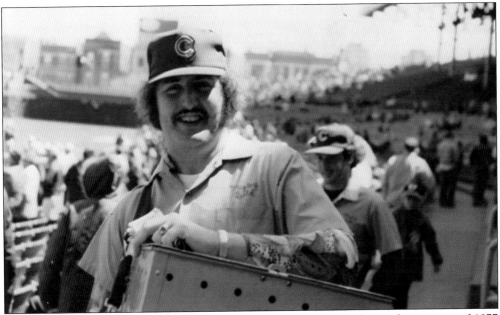

It was a bit unusual seeing Danny Redden selling hot dogs at Wrigley in the summer of 1977 because at the time, he was also in management across town working for the White Sox, with his father, Pat Redden, the boss of White Sox concessions. But the baseball schedule was such that then, as now, when the Cubs were in town, the Sox were on the road. So it was pretty easy to work fairly full seasons at both parks.

Many vendors started their careers selling soda pop, an item mostly for younger fans and not quite as prestigious as beer. Though on hot days or special kid's days, like Little League Day or Boy Scout days, vendors could make a killing selling it. Here, the memorable Sherwin Irwin is yelling his unique "Ice cold cola here Coke, a Coke-a Coke," which sold for 30¢ each in 1975, the price having gone up a whole nickel in 10 years.

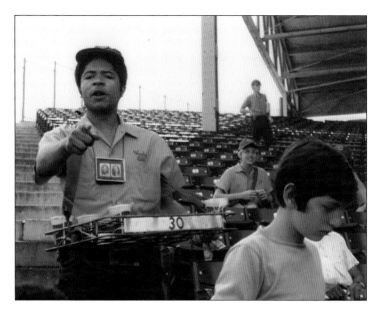

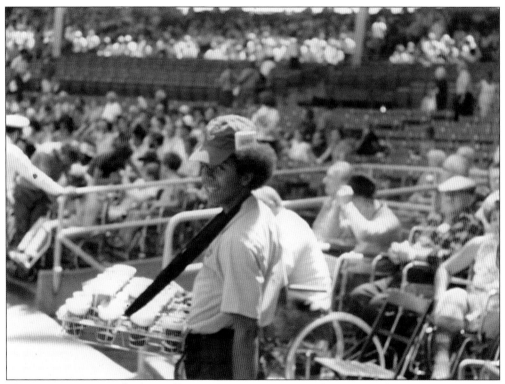

This is a young Darrell Rhea selling Coke in 1975. Up until 1971, Wrigley Field popmen were forced to alternate selling trays of 20 large Cokes for a quarter and small Cokes for 15¢ apiece. It was also a very messy item to sell, with the soft drinks frequently dripping all over one's shoes and pants, and making the change really sticky as well.

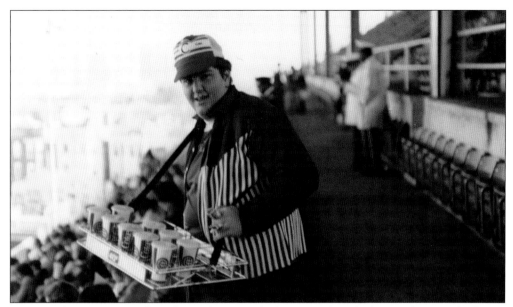

Here, Anthony Donato sells Coke in the upper deck in 1978, by which time the price had gone up to 40¢. Donato would eventually only work part-time because he got a "real job" as a Chicago bus driver, meaning he was expected to show up when told. Vendors were rarely scheduled to work games—they could work whenever they wanted, which occasionally resulted in not enough vendors on a busy day.

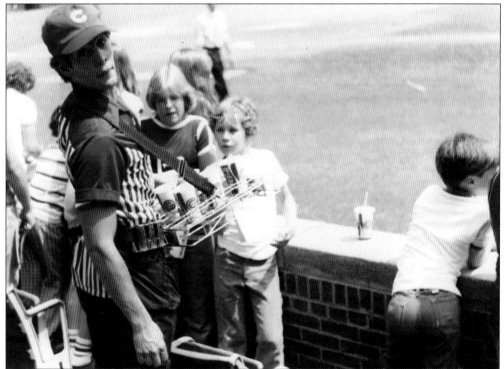

Scott Weber, shown selling Coke in 1978, was not what other vendors called a "lifer," meaning he worked a few years until he finished college and left for another job.

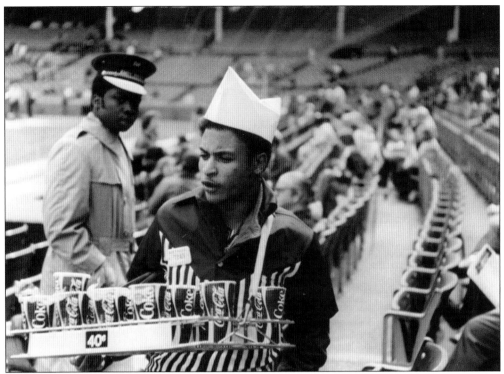

Optional, disposable paper hats were introduced for vendors at Wrigley Field in 1978. Here, Anthony Brown models one while selling Coke. Most vendors did not wear the hats, as they provided no protection from the sun and blew off easily. In 1980, however, they would become mandatory, until the folly of their existence blew them out of the ballpark for good by 1983.

Jim Barron is pictured with a full load of Coke. Vendors rarely took double loads of Coke because putting another heavy tray on top of an already full one would often cause the lower tray to spill even more than normal. But on fast selling days, some vendors would risk it, taking a double or even a triple.

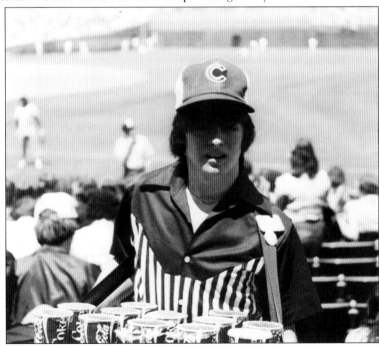

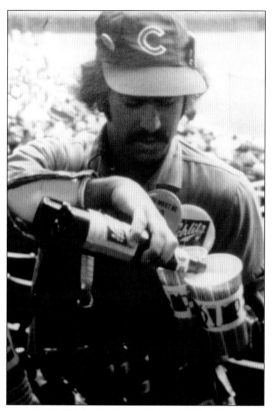

Paul Smulson, who would one day become a dental surgeon, drills a perfect two-bottle pour of Schlitz in 1976. Wrigley Field did not have refrigerators for beer until the 1980s, and brew in 12-ounce glass bottles was iced to make it cold. However, putting ice on bottles on a warm day and jostling them while climbing through the seats resulted in many exploding bottles—and cut fingers for beermen. (Courtesy of Paul Smulson.)

It is not surprising that Maria Mooshil became a vendor, or that both her sisters, Angele and Leah, did too. They had sports in their blood; their father was noted Chicago sportswriter Joe Mooshil. Here, Maria sells Coke, though it looks like pre-poured beer, introduced in 1978.

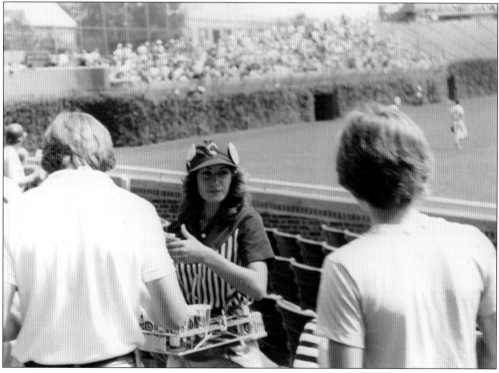

One of the greatest vendors of all time, in terms of selling the most cases, was Seymour Pechter. Sometimes called "S," which could have been for "Superman," Pechter excelled in attracting beer customers in very small crowds. He is pictured here in 1974.

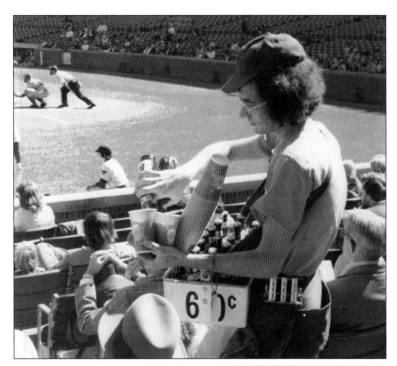

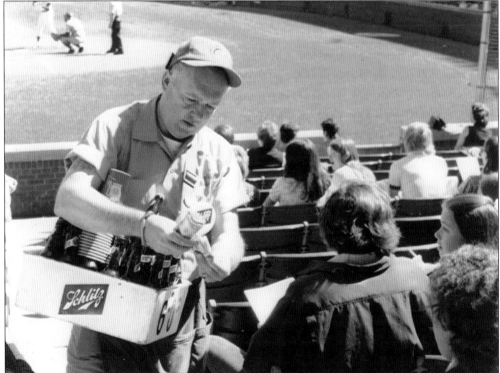

Ken Smith, known by many as "the Lampshade Man," sells Schlitz in 1974. He got the unusual nickname because he liked to pre-open a couple bottles and put cups on top of them, which gave them the appearance of lampshades.

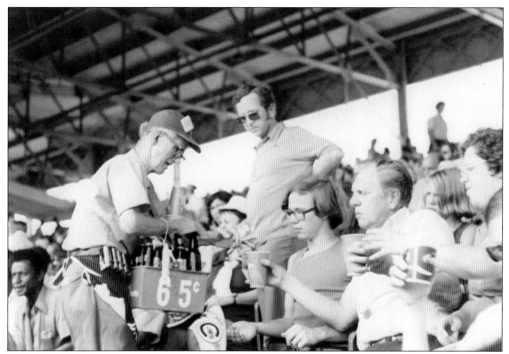

Due to the heavy weight of unrefrigerated beer cases that had to be iced down, many senior vendors usually switched to peanuts or other lighter items. But these two, Richard Cortopasi (above) and Ted Galuska (below), were up to the challenge. Cortopasi's nickname was, in fact, "Ol' Man," though that was to properly distinguish him from his son Dennis and grandson Ronny, who also were vendors. Galuska actually deserved that title as he sold beer in the seats until he was in his 80s.

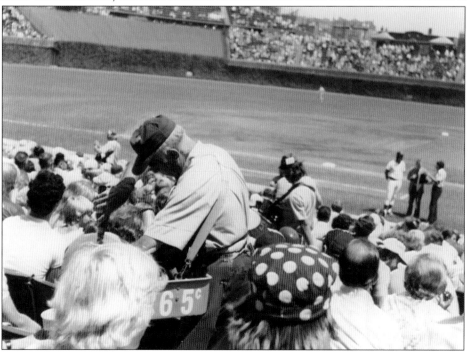

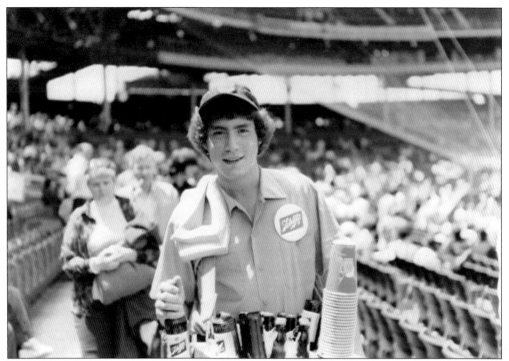

Among the most frequently asked questions of vendors by fans is "doesn't your shoulder hurt?" The answer by the majority of vendors is "you get used to it." These two, Larry Weiner (above) and James Haralson (below), did something about the pain by using foam rubber padding on their straps to protect their shoulders.

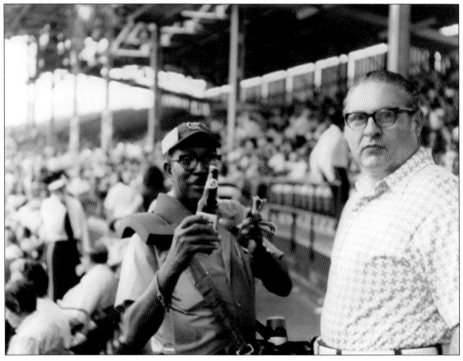

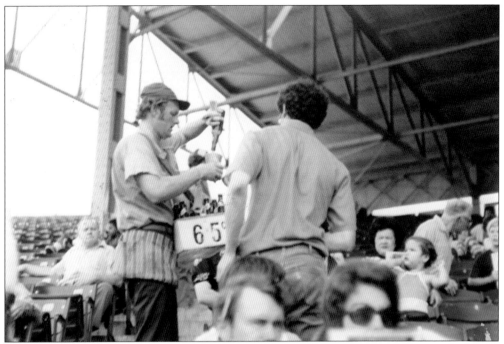

One of the most famous and cherished tools of Chicago's beermen in the 1970s was the Zuiker opener, which fellow employee Francis Zuiker made as a sheet metal worker. They were completely unbreakable and opened bottles with precision. Zuiker sold them for only $1 each. Looking closely, the opener can be seen on these guys. Above is Zuiker's oldest son, Joe. Joe was one of several Zuikers who toiled at the ballpark. His opener dangles from his right wrist, while in the photograph below, Pat Halloran is holding one in his right hand.

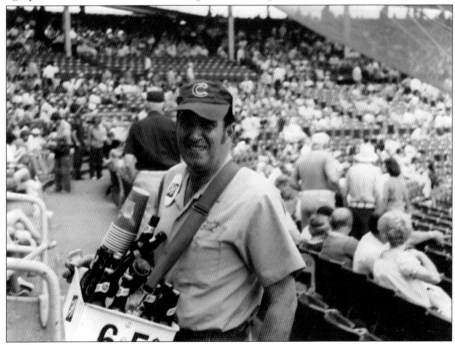

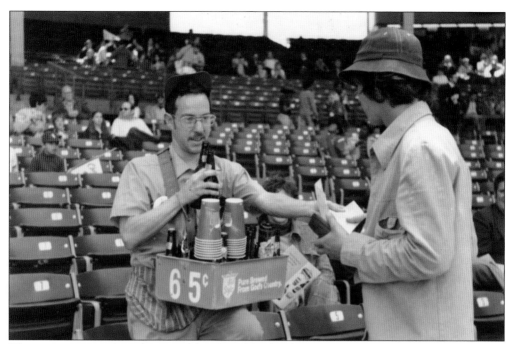

These two images of Mitch Levin (above) and his brother, author Joel Levin (below), illustrate a beer vendor's day at Wrigley Field in the mid-1970s. Mitch is full of energy and enthusiasm as he completes his sale. Note he is returning the young-looking customer's identification that proved he was of legal drinking age. Joel, on the other hand, is showing the effects of carrying the 50-pound Old Style beer case on a long, hot summer afternoon. He looks as though he wants to check out and go home. He probably wishes it was the 1969 Cubs season again when he carried triple loads of Frosty Malts to the upper deck in front of sold-out crowds. Everyone loved Frosty Malts.

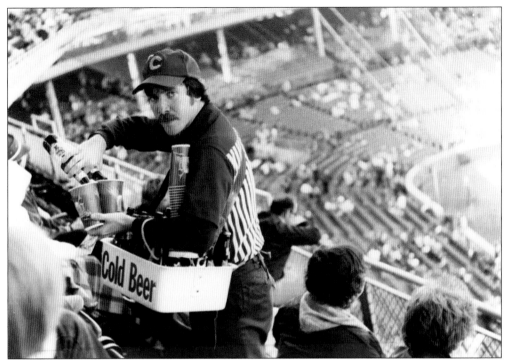

Among the many challenges of vending, as in most occupations, is transportation to the workplace. However, for ballpark workers it can be a bit more complicated, as they also have to factor in game day traffic as well as hard-to-find free parking. It was unthinkable for employees trying to make some hard-earned money to have to spend it on parking, of which Wrigley Field had very little, and free street spaces not always easy to find. Things got even worse in the late 1980s with increased neighborhood parking restrictions once night baseball started. These two beermen, Arnold Lipski (above) and Eric Eckstrum (below), made things a little easier by carpooling.

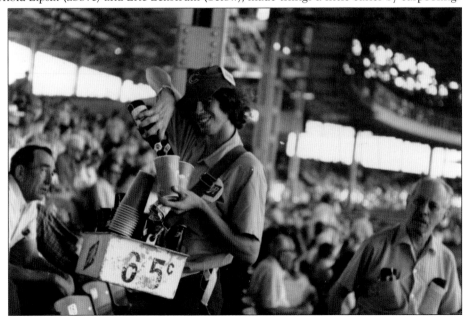

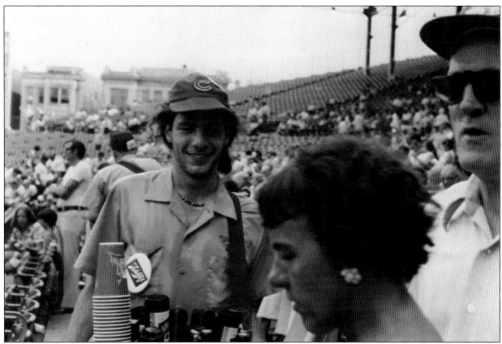

Ronnie Blank (above) and Lane Kaplan (below) did what a lot of vendors do by turning some of their bottles upside down. This either meant they were empty so they could quickly find unopened ones, or they had returned to the commissary for another case but still had a couple unsold beers left over. They would jam the old ones into the case because there was nowhere else to put them. This jamming, however, was one of the reasons the bottles frequently broke. Vendors had to be extra careful to avoid needing first aid—and losing time selling. Most beermen carried bandages for this expected calamity.

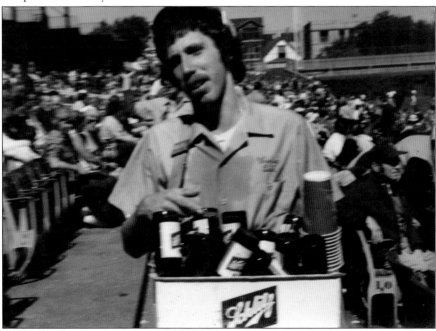

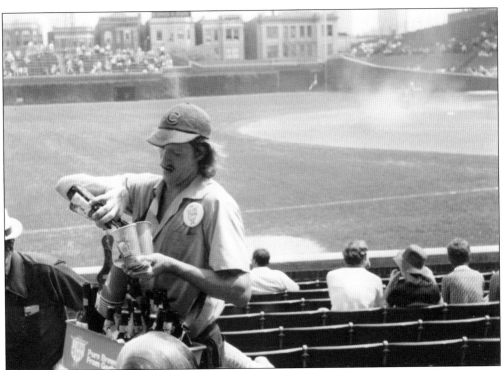

One of the unpredictable benefits of taking pictures is finding unexpected things in the background. Eugene Skonicki Jr. (above) pours beer while off to the right a strange cloud of dust starts to gather from a gust of wind. Meanwhile, Grady Morris (below) pours a couple of Old Styles while getting a very sour look from a fan at left, who has one of the strangest head coverings in ballpark history.

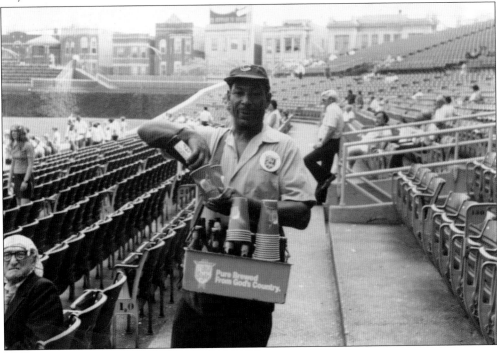

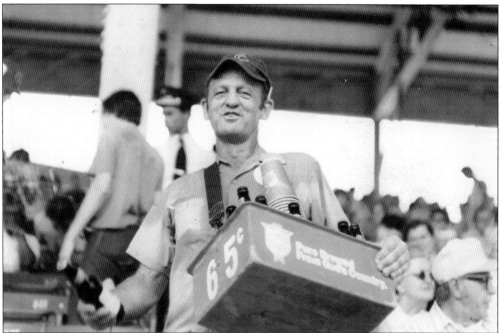

"Rookie" William Griffin takes the meaning of hard work to a whole new level. During the game, he sells beer in the aisles at Wrigley Field. As soon as the game ends, he joins the ground crew to help sweep up those very same aisles. "Griff" is the longest-serving vendor at Chicago's ballparks, having worked over six decades. He now sells programs, after putting down the beer case and broom years ago. Movie fans can see Griffin in *Rookie of the Year*, a 1993 film set in Wrigley Field. He plays a third base coach and has an Oscar-worthy performance of arm waving—Hollywood always had an eye for talent. He is pictured above in 1975 and below in 1978.

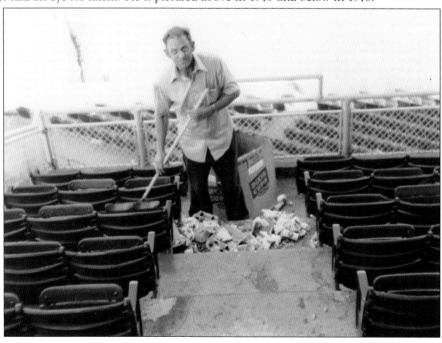

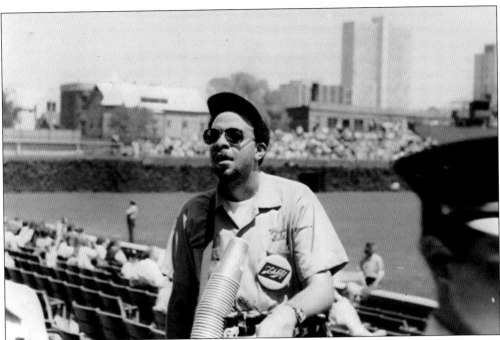

One of the more unique challenges of vending at the ballpark is finding where to sell. No one is assigned a specific aisle, though vendors are assigned to different commissaries around the park where they pick up their product. It is more advantageous to try to sell closer to the commissary for quicker sales, but since everybody else has the same idea, vendors have to look for an open aisle, with no vendors selling that item. Here, Henry Woodson (above) is looking for an aisle while Fred Elikan (below) sells in another. It was bad business for more than one vendor to be in the same aisle on the same item, and it caused fights if a guy was cut off and sales "stolen" from him. These two guys were pretty tough, though, and woe to the cutthroat who tried to chop them.

This sign reads, "Attention vendors. No load will be issued unless both parts of ticket are given to checker." This is the third base cashier's room where Harry Pinchowsky is getting his X tickets. Vendors start their day receiving a two-part ticket—one side read "merchandise" and was torn in half in the beer room, known commonly as the "wet room." Sellers would keep the half of the ticket that read "commission."

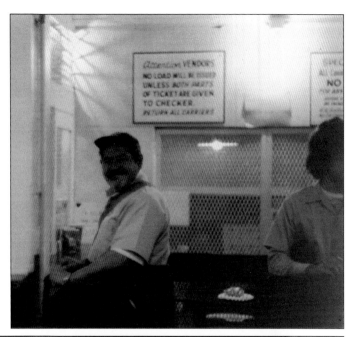

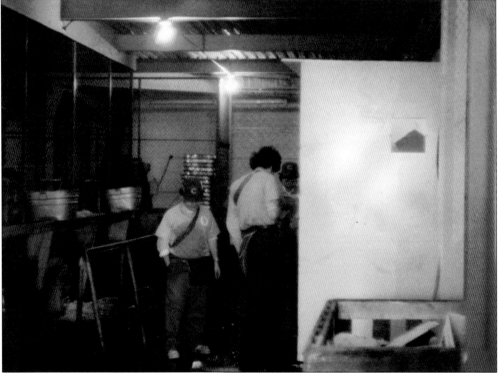

Cousins Paul (left) and Seymour Pechter wait in line in the right field commissary (though it was actually down the first base line). It was not built until 1969. Prior to that, all vendors came from the other side of the park, meaning fans out there often did not see as many hawkers. After men were given their free X tickets, they paid for the rest of the loads and paid for their first load when they checked out.

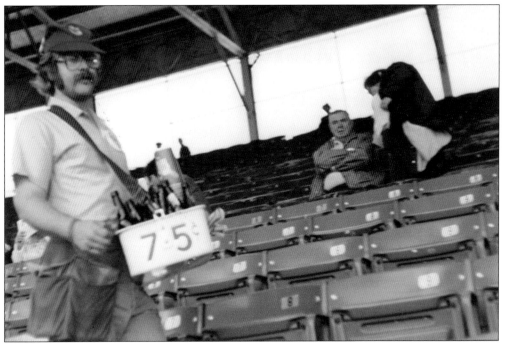

In 1977, the price of beer skyrocketed by a dime to 75¢. Gone were the familiar green carriers for Old Style. They were replaced by shiny new white ones—the same color as the Schlitz cases, which caused some confusion for fans. This would also be the last year that the downstairs seating area featured bottled beer. In 1978, the vending world was shaken up by the introduction of pre-poured beer. David Ashkanazy (above) and Mike Gold (below) are oblivious to the coming dark period for suds sales, which lasted five long seasons.

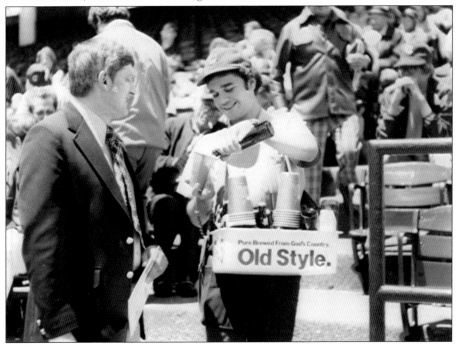

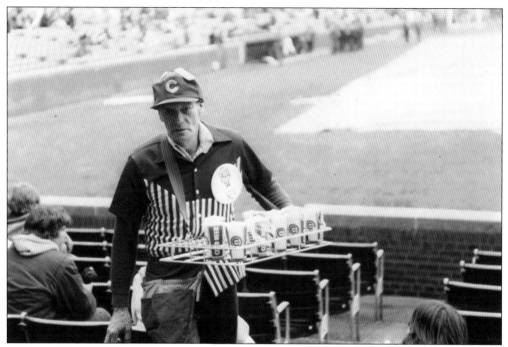

Vendors at Wrigley Field sported new uniforms in 1978, instituted by a new company that ran the ballpark concessions. Until that year, the north side ran its own concessions, but then Arthur Food Services, which had been servicing the Los Angeles Dodgers since 1961—and would until 1991—took over. Terry Arthur, the son of David Arthur, who had invented the famed "Dodger Dog," was the new chief. Arthur believed he could improve the beer experience with pre-poured beer in cups, much the way soda pop was prepared for sales. Here are Bob Rose (above) and Johnnie Skweres (below) putting on brave faces to sell the strange new item in April.

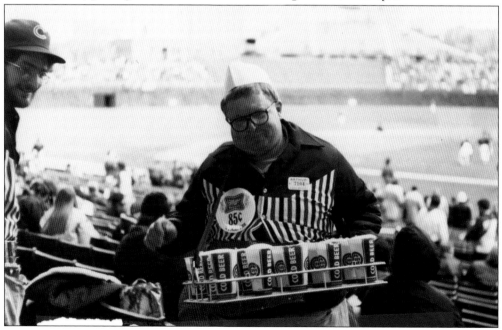

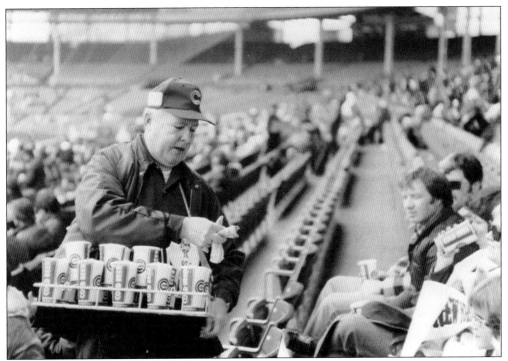

Ken Smith (above) and Howard Spiegel (below) do their best to interest fans in the new way to consume a cold one. Problems, however, getting an actual cold one became evident as the season warmed up. Unless a vendor could sell out his tray quickly, in 10 minutes or less, the brew kept getting warmer and warmer in the paper cups, unlike iced-down bottles.

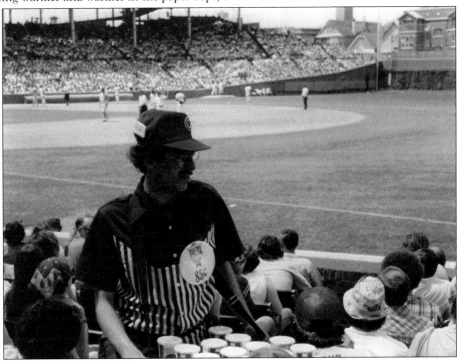

Dan Smulson exhibits his overloaded tray of the new pre-poured beer. Vendors like Smulson found it necessary to return to the commissary for a fresh cold load despite still having several beers left from their current one. Fans had quickly realized that if a vendor only had a few cups left, his product probably was somewhat less than chilly, and they would just wait for a guy with a full tray.

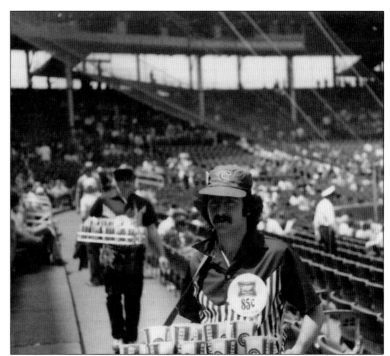

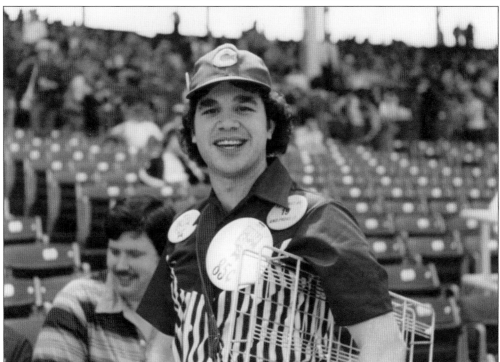

In addition to new uniforms and a new way to quench fans' beer thirst, in 1978, the cost of beer went up another dime, to 85¢. Broadcasting that new price were bigger buttons. Mike Gold, pictured here, has another yellow button denoting a new beer sales policy—"You must be 19 to buy beer"—a change in Illinois law that lasted just two seasons.

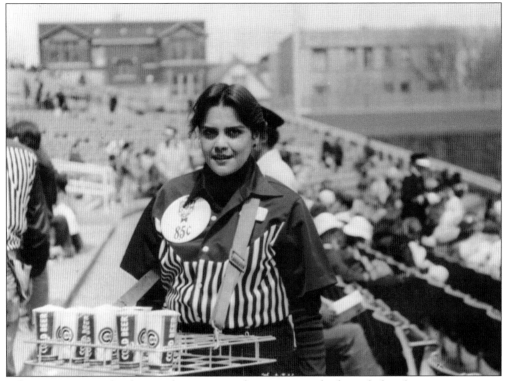

A beerman tries to develop regular customers by various methods, including being courteous or clever when interacting with potential drinkers. However, they all had trouble competing with a beerwoman. With the adult fan base about 80 percent male, it was fairly easy for Sylvia Alvarado to quickly become one of the top selling beerpersons in her rookie season. She is pictured here in 1978.

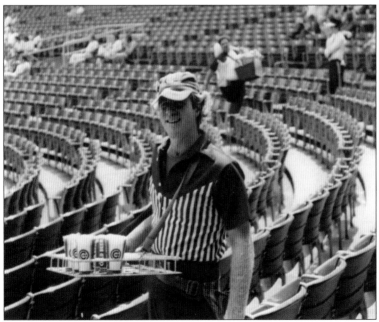

Among the top-selling vendors in 1978's new world of pre-poured beer sales was Peter Breen. He knew something about trying to compete with beerwomen because two of them were his sisters, MaryAnne and Linda, known as "The Breen Queens."

Evan Pomeroy, desperately shouting for customers here, was famous for at least two things—he was Lloyd Rutzky's next door neighbor before he was a vendor, and he once wore a pair of discount-store gym shoes to the park. It was a good day for sales, but he was barely able to walk. He sold very little.

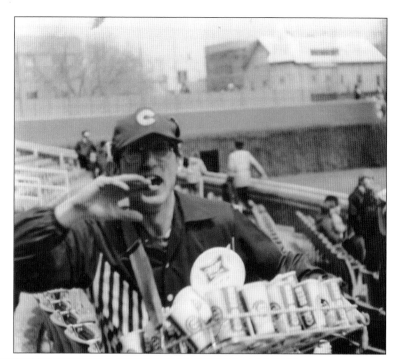

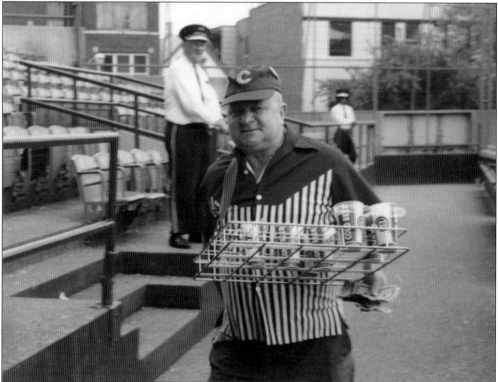

Herman Klingbeil was nicknamed "Bowling Ball Man," though no one ever seemed to know why. However, here he is rolling down the ballpark lanes pretty quickly and looking kind of like he maybe wanted to "strike" the photographer, Lloyd Rutzky.

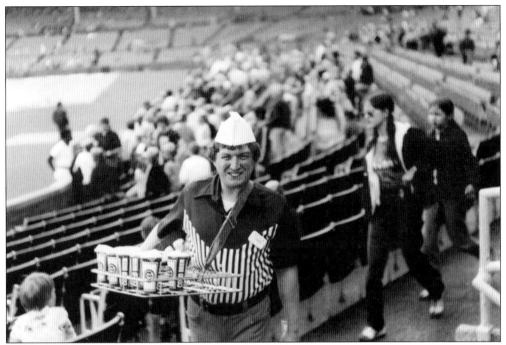

Paper hats were still optional head gear in 1979. Harry Rachman sports one on a gloomy day with rain threatening (note the tarp on the infield). There was obviously no strict dress code for pants, given Rachman's oddly colored ones.

The Chicago Fire Department Engine Co. 78 firehouse is directly north of Wrigley Field on Waveland Avenue, with Seminary Avenue on its western side. Built in 1915, it replaced a one-story 1894 structure and was a typical hangout for vendors before getting their assigned items. Here, in 1996, (from left to right) Steve Czyzniejewski, Frank Bellizzi, Mark Goldberg, Ken Sherwin, and Bob Kosiba take it easy before a game.

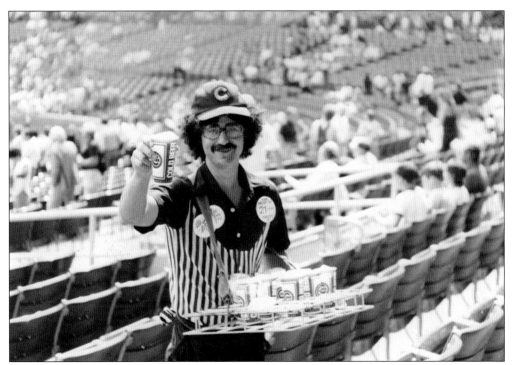

Ken Dolin liked to "jump early," as vendors called it. Jumping early meant that a vendor was the first to take a load out and get to customers before the competition. Being paid on commission meant a vendor could start selling and take breaks whenever they wanted.

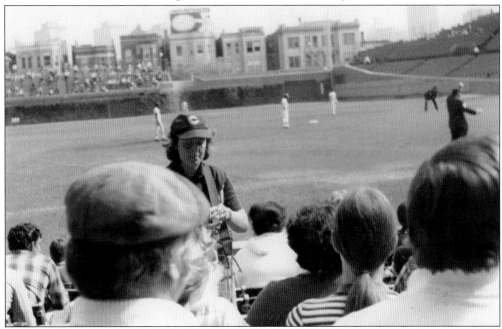

Cindy Fosco made sports vending her life's work, in more ways than one. She fell in love with another vendor, Dave Gaborek, and married him. They then transferred their success in ballpark sales to a sporting goods shop and opened Let's Tailgate, slightly north of Wrigley Field in Evanston.

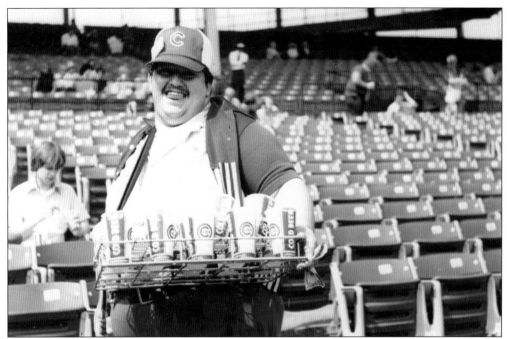

Leonard Czarny (above) and Mike Weiner (below) cheerfully sell their pre-poured beer in either blue cups or red ones. In 1979, only the lower section of seats, upstairs or down, were reserved boxes. As Cub games increased in popularity in the mid-1980s with the coming of announcer Harry Caray, gradually every seat could be bought in advance, including the bleachers. But before that, there were times when large crowds would arrive to buy day-of-game grandstand seats—about 24,000—by 9:00 a.m. and the gates had to be opened much earlier than scheduled to avoid street overcrowding. However, fans holding tickets would not arrive until nearly game time, at either 1:00 or 1:20 p.m. Vendors could easily sell several loads in the grandstands before it was worth it to "go low."

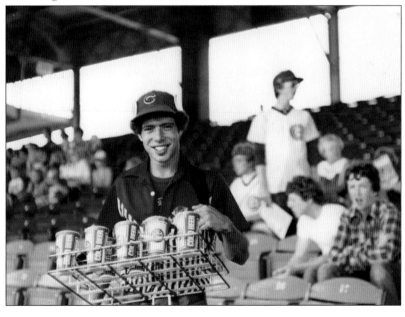

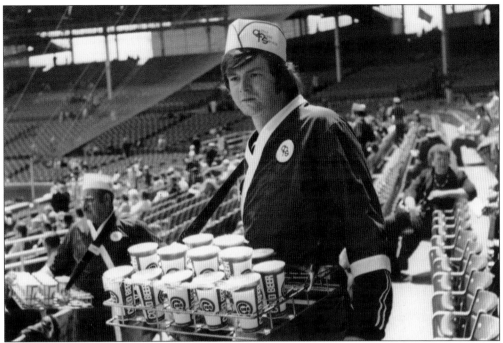

The year 1980 at Wrigley was the year of the vending fashion statement. Ron Deedy (above) sells pre-poured beer in the new, bright red bathrobe and white paper hat that seat workers now had to wear. Steve Sheppard (below) also sells pre-poured beer in the strange new getup. However, a solution had arrived for the continuous dripping of beer from cups. The turquoise-colored tubs held the beer trays and allowed the spillage to accumulate into the tubs instead. The tubs were emptied after each load. Unfortunately, there were not quite enough of them for everyone.

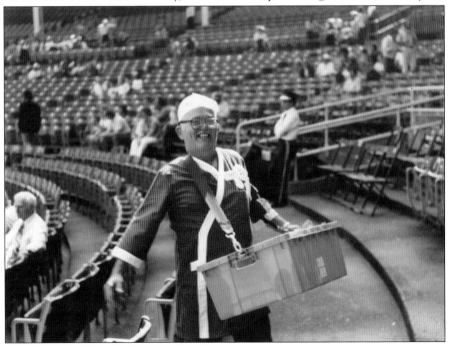

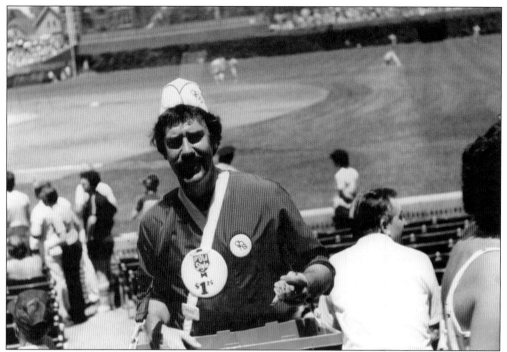

The date was June 7, 1981, and beer vendors Robert Warsaki (above) and Jim Smulson (below) were about to be out of work for most of the summer. Five days later, Major League Baseball players finally called the strike they had been threatening since the previous May. The "summer without baseball" saw no regular season games played from June 12 to August 11. It was a vacation nobody wanted.

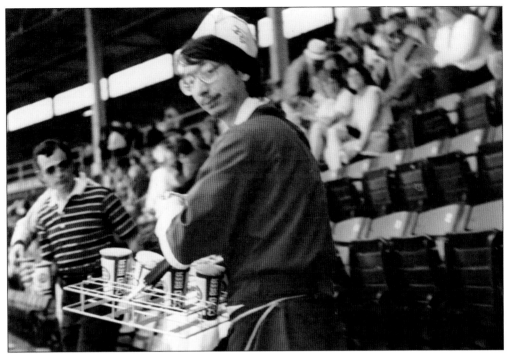

Here, Les Medoff shows off the back of the red bathrobe in 1980. The bathrobes went out of style after two seasons. Below, in 1982, Paul Shimbo is looking elegant in his dark blue frock with matching light blue tub. Both are sporting the nonfunctional paper hats that caused sun blindness for the hardworking troops. In addition, the head coverings regularly blew off into the crowd and onto the field.

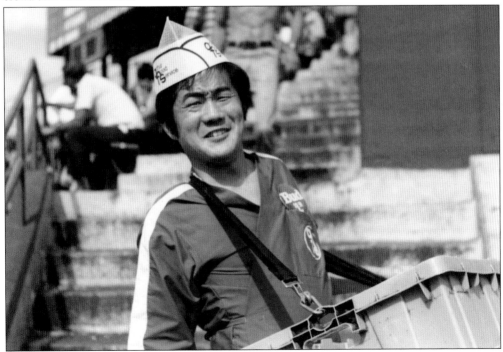

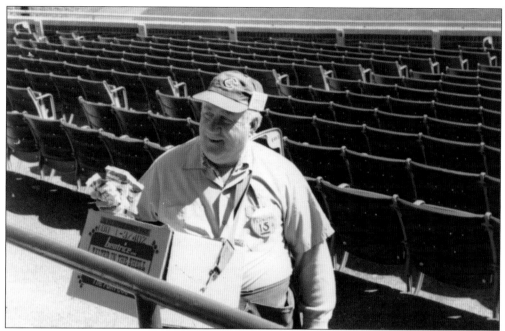

Two icons of vending in 1974 were Llewelyn "Lew" H. Tidd (above) and Max Craman (below); both usually sold peanuts. Tidd was completely lovable, in both looks and his call: "B-nuts—pipteen cents—2 per quarter," which had to be heard to be appreciated. He was not giving a volume discount though, that was how peanuts were sold—a small bag for three nickels or two smaller bags stuck together for two bits. Craman, on the other hand, made up his own sign to attract sales. It reads, "Little cubbie says 5 pennants in the past, 2 World Series, next pennant coming up," referring to the last two World Series at the Friendly Confines he claimed to have worked, in 1938 and 1945. The pennant he was predicting was still 42 years away.

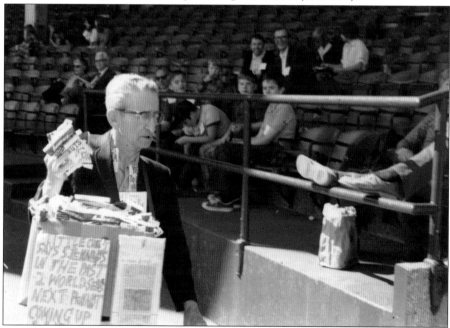

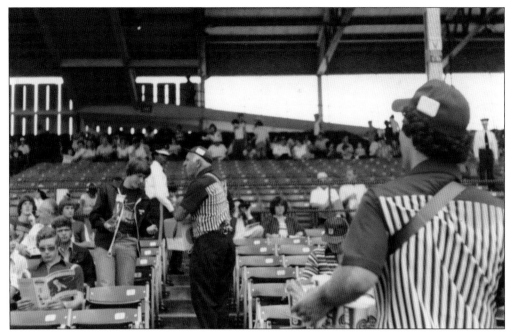

Vendors on the same item did their best to stay out of each other's way; however, some items complemented each other and often fans would not buy one without the other. It appears here that Eli Lawrence, on beer, is yelling at the "nut" guy nearby to come over and sell somebody some peanuts so Lawrence could make a sale. But that guy was Bernie "The Roadrunner" Lasinsky, and he was probably moving too fast to hear Lawrence.

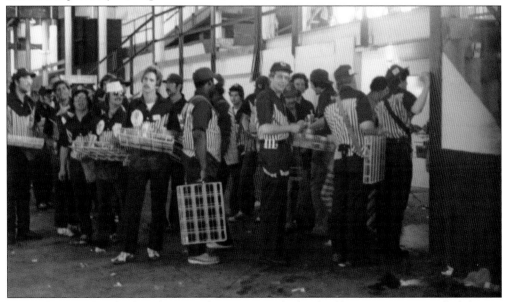

Pictured here is the checkout line. Vendors wait outside the third base commissary, called the wet room, to turn in their commission tickets and have their daily pay receipt added up. They would then take that receipt to the cashier's room to be paid, minus taxes. Looks like several of them have unsold beer in their trays to return, victims of oversupply and under demand. (Courtesy of Mike Gold.)

The song goes "Buy me some peanuts and crackerjack," and Rick Hara (above) and Hymie Rubin (below) strike amazingly similar poses displaying this all-time favorite combination.

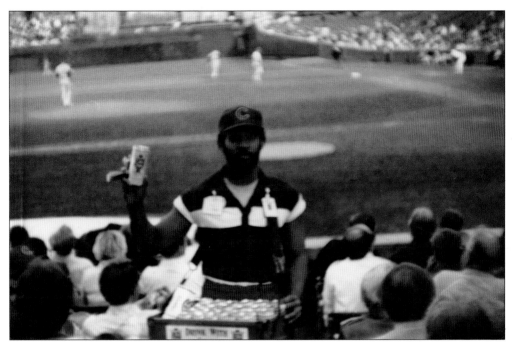

The end of every baseball season is sad, knowing that the boys of summer are about to hibernate. The year 1984 concluded with the Cubs' crushing defeat in San Diego, but it was their first trip to the postseason in 39 years. The year 1985 showed great promise; however, in mid-May, two of the Cubs' top pitchers, Cy Young winner Rick Sutcliffe and ace southpaw Steve Trout, suffered severe injuries, and the team plunged out of contention. Wrigley Field became a "house of pain" for the vendors too, with near-record low attendance. These two beermen, Lee Cook (above) and William Dennis (below) happen to be familiar with this agony, as they were and still are experienced weightlifters and advocates of the "no pain, no gain" philosophy.

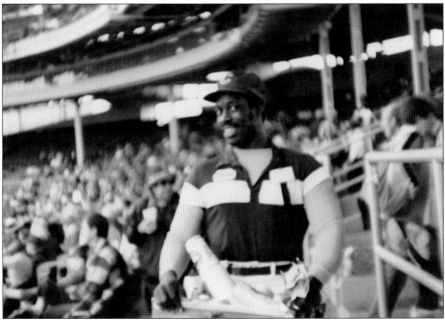

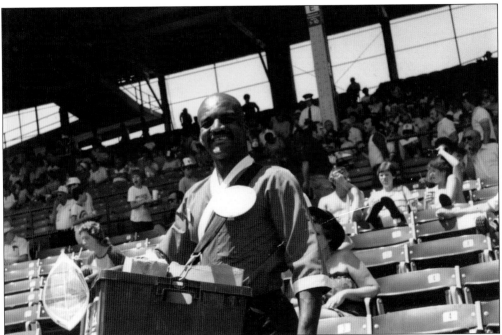

Annually, vendors look forward to the All-Star Break, a few days to get away and come back refreshed to finish the season. Unfortunately, one of the saddest days was coming back from the break in July 1982 and learning that this smiling, wonderful guy, Jim Riles, shown here selling popcorn, had drowned during those three days off. He was sorely missed.

"Surfin' Bird" was a top five Billboard hit in 1964 and the theme song of this guy. Mark Rosenfeld, nicknamed the "Nerd," flies the nearly empty aisles in 1977 just after the gates opened: "Everybody's heard about the nerd, nerd-nerd-nerd, the nerd is the word."

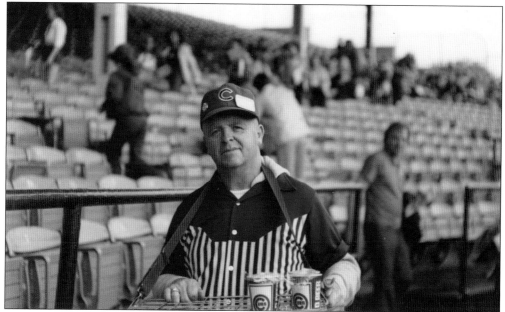

Virgil Darling vended at minor league games shortly before advancing to the major leagues of Wrigley Field. He is showing here in 1979 making a rookie mistake, one he would quickly correct. He has his strap around his neck instead of over his shoulder, which would cause severe neck damage. For years, vendors in television commercials were portrayed wearing the strap the wrong way.

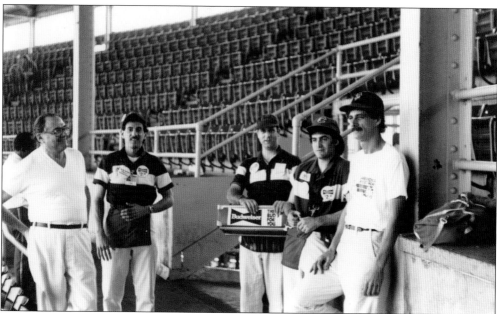

Before the full upper deck crowd would come in, there were not enough sales for everybody, so vendors would take turns for easier sales; it was called rotating (RO). Pictured are Sam Arkules (left) and Ira Levin (right), who must have been last in RO as they are still out of uniform. Glenn Smoler, at center, is next to go out and has his case on, but empty. Ken Sherwin and Randy Antlept wait on either side of him.

Two vendors are pictured acting wild in the more relaxed times of the mid-1970s. Corwin Glick (above) and author Lloyd Rutzky (below) could be reprimanded for wearing their hats backwards and making unprofessional faces. But in the heat of long games, behavior like this was occasionally forgiven. In the coming seasons, as crowds became much larger, these guys were expected to grow up.

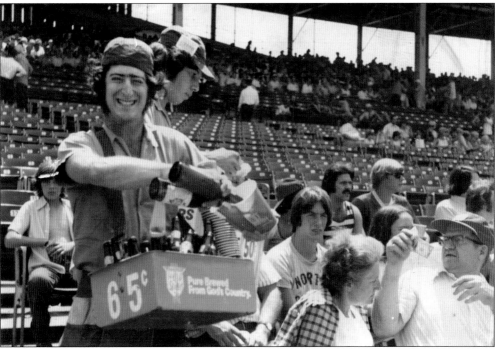

Roger Sosner exits the third base wet room with his Old Style case properly iced. The commissary checker, his ticket puncher in hand, prepares to invalidate Sosner's ticket; if it was lost by management and found by a vendor, it could not be reused for a free load.

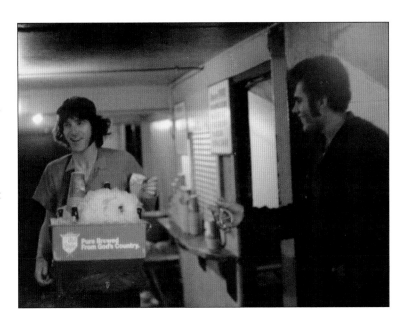

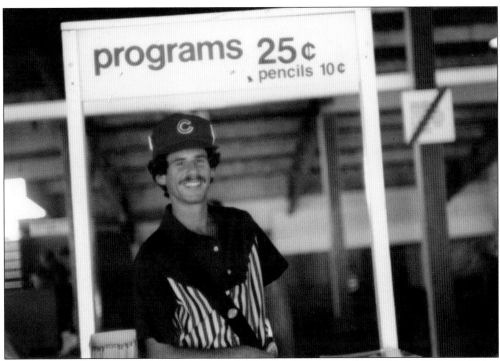

Beerman Lyle Cohen seems to be selling the wrong item. However, he was only covering for his uncle Harry Altman, who had to take a restroom break. Unlike regular vendors who had the opportunity to go between loads, program guys were pretty much stuck unless they could find a friend (or relative) to relieve them.

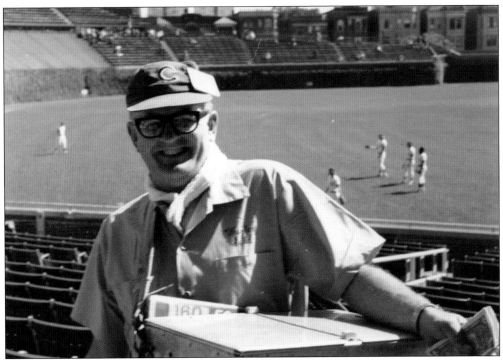

Hot dogs and pizza, pizza especially, were often kept very hot for sales in the seats with flaming cans of sterno in the metal carriers. Above, Jim Bendas has crafted a thick piece of cardboard, probably taken from a crushed peanut box, between his hot pizza box and his stomach. It was not a perfect defense system, but no one ever came up with a better one. Maury Kravitz (below) also has a cardboard protector protruding around the side of his heated carrier.

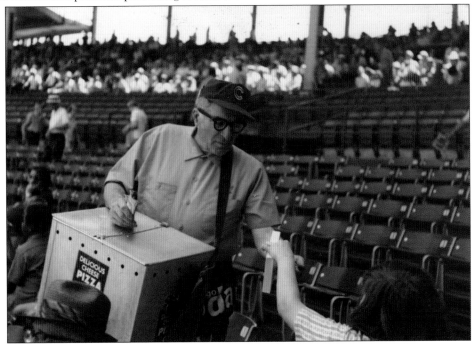

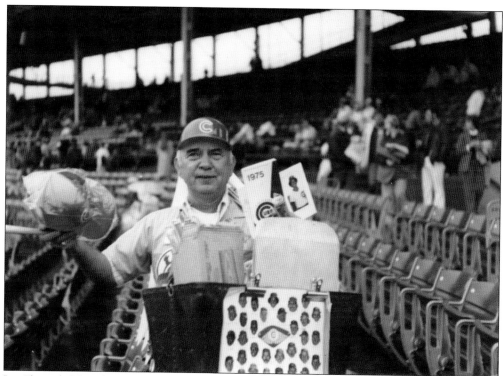

Joe Zbacnik (above) and Vincent Kasher (below) sell souvenirs in the mid-1970s. Novelties were considered the best item to sell. The older guys with the most seniority either sold in the seats, like Zbacnik is, or had a stand, like Kasher. However, the higher pay also involved more work, as souvenir guys had to fill out multiple forms before and after each game.

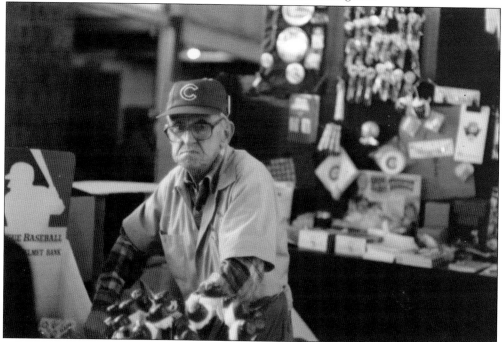

In 1976, a teenage John Studnicka Jr., son of the union steward at Comiskey Park (who was known as "Chicago John"), sells souvenirs at Wrigley Field about 20 years before he would become union steward there. Behind him is a much younger Charles Deless, son of John Kurpiel, known as "Boston John," a souvenir vendor.

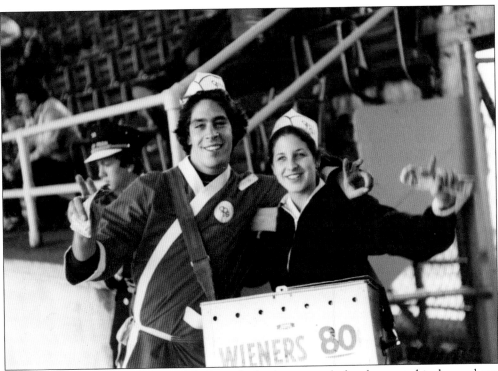

Howard Kadet, in his Arthur Food Services bathrobe, pauses before he starts his day on beer. He usually finished his day right outside Wrigley Field selling various souvenirs, mostly topical T-shirts. He is pictured here alongside hot dog woman Melinda Korer.

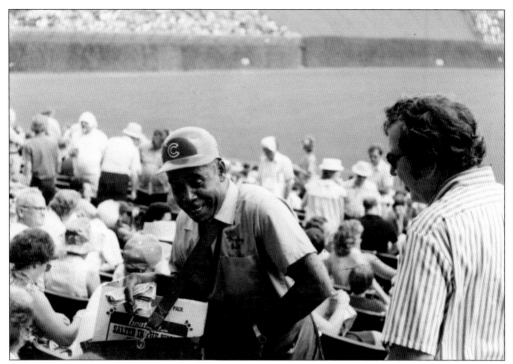

Lenford Leake (above) was a local entertainer teamed with his non-vending brother in an act called The Leake Twins. Lenford regularly delighted the fans with his altered versions of popular tunes, substituting his item into the song lyrics. Above, in 1975, he was probably adapting Morris Albert's top 10 hit "Feelings" by crooning "Peanuts, nothing more than Peanuts, trying to forget my Peanuts, my Peanuts of love." Mark Reiner, pictured below selling pre-poured beer in 1975, was a big fan of Lenford's tunes. Many years later, Reiner decided to pay homage to the famed Leake and attempted to boost beer sales by the same method. He could be heard with a version of Queen's huge hit "We Will Rock You" with lyrics like "We will, we will serve you."

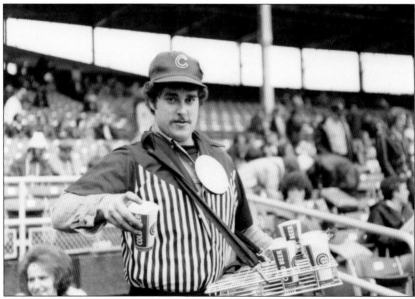

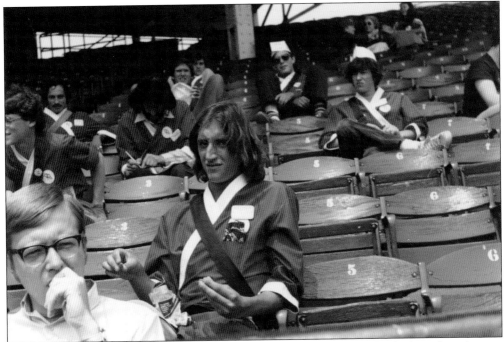

Long-haired Tom Albert, front and center, eats his lunch in a sea of red-robed vendors. Among the "Crimson Crew," five rows behind Albert and wearing dark glasses, is the most appropriately named seller of suds, Jack Beerman.

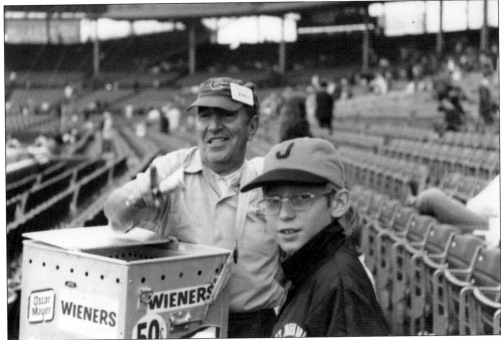

"Eat, eat, eat—it's a quarter pound of meat" was Abe Kandell's famed call when he sold hot dogs. Kandell's interview was among the many highlights in a documentary film about vending in the late 1970s. The film, entitled *The Sound of Money*, was made by fellow veteran Mark Reiner.

Dave Comrov was one of the eager young beavers of vending in 1968. Nicknamed "Hopper" for his ability to quickly leap over rows to beat others to sales, here he is selling the famed Frosty Malts that he sometimes would toss to kids with the necessary wooden spoon tucked perfectly at the bottom—but only after those kids had tossed him a quarter. (Courtesy of Fred Homer.)

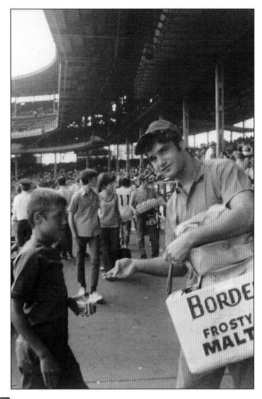

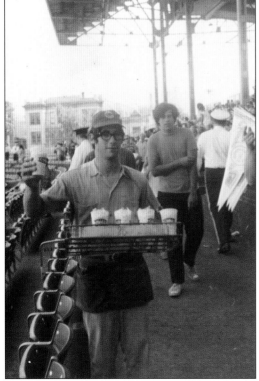

Fred Homer peddles a tray of Coke. Like Lloyd Rutzky, and millions of fans too, Homer also took many memorable pictures of this iconic ballpark. Here, he takes a break from snapping photographs as he loans his camera to a buddy for a portrait in 1969. (Courtesy of Fred Homer.)

Is this the most fun job young men can have? It sure looks like it in these two photographs from 1970 in the upper deck at Wrigley before strapping-up time. At left are Les Medoff, Mike Ginsburg, Maury Rosenblatt, Myles Pomeroy, and Bruce Fish (among others) going more than a bit nuts. Below, included in the crew tipping their caps to the fans who so enjoy this daily show of hawking, are Bob Kraupner, Steve Fish, and Steve Drexler. (Both, courtesy of Fred Homer.)

Three

WE'RE A TEAM

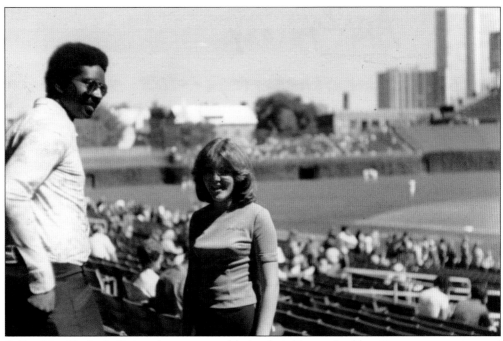

Polite, friendly Andy Frain ushers, memorable for their blue and gold uniforms, were an integral part of the Wrigley experience. They were exceedingly knowledgeable about game time, seating directions, concessions, and directions to the closest washroom. Pictured here in September 1976, usher Anne Friday is telling a fan where his seat is.

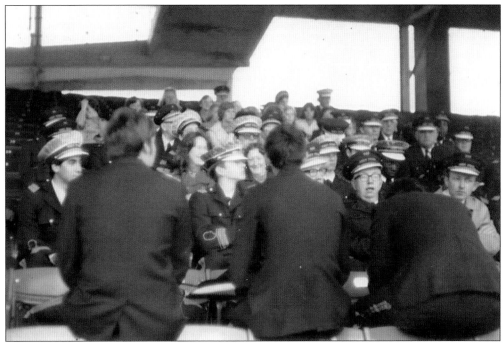

Rain was definitely in the forecast as these two groups of Andy Frain ushers meet to get their day-of-game instructions in June 1976. (Note the plastic hat covers some are wearing.) A key part of the usher's job was to do their best to quickly diffuse unruly incidents. Their presence prevented many fans with grandstand tickets from sneaking into the reserved box seats. Of course, the ushers did let autograph seekers into the box seats to get autographs of their favorite players, but only if they got to the stadium early.

Andy Frain ushers, just like vendors, must brave the elements at Wrigley Field. Tammy Hrizak (above) appears to be enjoying her assignment in the box seats along third base during batting practice on this pleasant August 9, 1978. Short sleeves and shorts were all that the temperature demanded. However, it was quite another story for usher Val Orvino (below) on September 28, 1980. Here, she is trying to keep her hands warm while still smiling bravely from the box seats near the visitors' dugout.

Here are two Andy Frain supervisors at the start of their workday at Wrigley Field. "Supers" were easily recognizable by their white caps since the rank and file of Andy Frain ushers wore blue ones. On an extremely hot day in 1977, Stan Imbior (above) has boldly removed his jacket, though he is still in long sleeves. Conversely, in 1980, Ralph Wilson (below) looks sharp even with one of his jacket's buttons undone.

Security officers conducted themselves with professionalism and dignity as they patrolled all corners of Wrigley Field. Whether there were large crowds or small turnouts, they enhanced the experience of going to this legendary ballpark. The officer above is impeccably dressed for duty in 1980. The photograph below, taken in June 1976, features, from left to right, Mark Harding, Joe Dawson, and Alvis Waldo before they went on patrol.

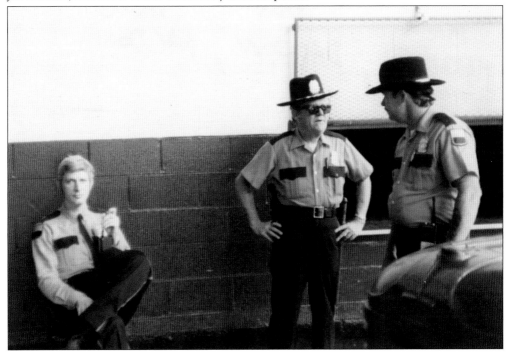

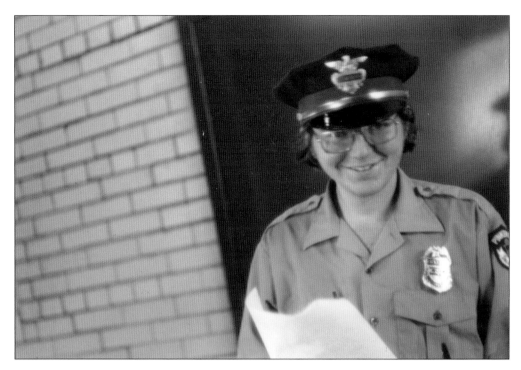

Here are two smiling Pinkertons under the stands, cheerful because they are working at America's most beloved ballpark. Above is Andy Mastin in August 1978. Below is Linda Montes in May 1979. Note the significant uniform change for Pinkerton employees between the two seasons. However, the badges on their left arms remained the same.

Vendors wore uniforms in the 1970s, so there needed to be employees who costumed them for this distinct occupation. The rigors of walking up and down concrete stairs with jostling bottles of beer or leaky soft drink cups meant clothesmen were always kept busy supplying new duds every day. During the game, these clothesmen would suit up and vend too. The above 1972 photograph shows "Little Al" Weiler walking to Wrigley Field by the famous corner of Clark and Addison Streets to begin his double duty day, while below in 1978 is Mike Rubin, who occasionally helped Weiler out with uniforms, which were distributed in the main office of the union steward.

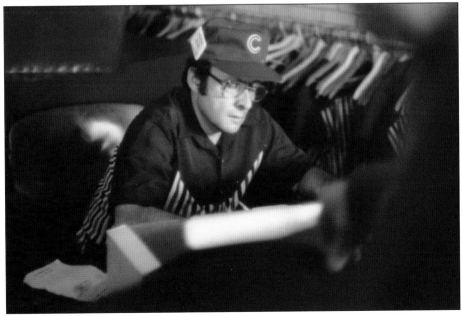

Hundreds of rolls of quarters, nickels, and dimes. Thousands of dollars changing hands in a few hours. Brightly colored rolls of merchandise tickets on spindles over one's head. Shouting vendors wanting instant service. Daily wage statements that must be accurate. Cramped office space. Partial loads with returned items. The life of a Wrigley Field cashier was not an easy one, but these four ladies handled their jobs with a calm demeanor and intelligence that had all the numbers balanced all the time. Above is Marge Frank in 1976. Below from left to right are Lorraine Grazier, Jesse Berg, and Pat Joyce in 1975.

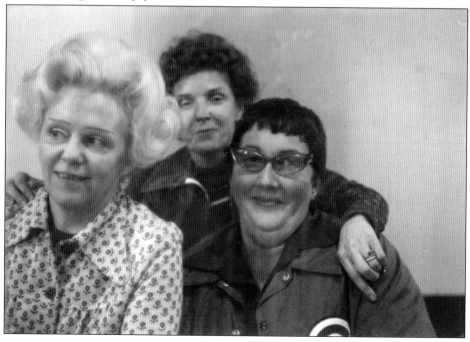

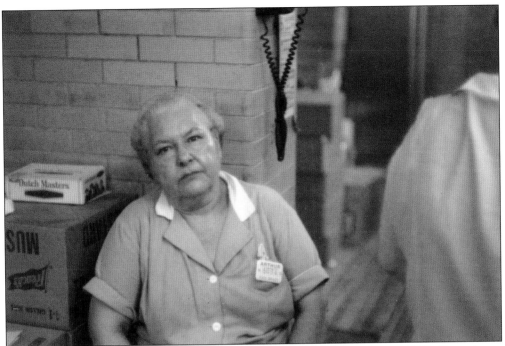

Here is an inside look at life in the "dry room" at Wrigley Field, in August 1978. Commissary workers there cooked, wrapped, and packed hot dogs into Oscar Mayer metal boxes daily. Popcorn was popped and bagged before being counted for the large brown bins the vendors would carry. They also collected individual merchandise/commission tickets from the vendors and tallied up their totals at game's end. Eleanor Gioa, dry room supervisor, is pictured above after a busy day. Evelyn Kessler (below, left) is shown in discussion with Gioa surrounded by boxes of French's Mustard and Beatrice Peanuts.

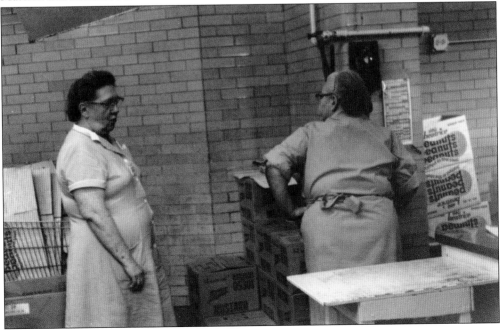

Wrigley Field has always been family oriented not only for its fans, but for its employees as well. The above image shows Bob Dodro and his wife, Jo Anne, standing outside the dry room in 1975. Partially visible at right behind the metal screen is Jo Anne's mother, Eleanor Gioa. Mother and daughter frequently worked together in the dry room while Bob was a vendor at Wrigley Field, before he became an accountant. The photograph below, taken in 1978, captures Fred Gioa (Eleanor's husband and Jo Anne's dad, at left) with commissary boss Wendell Schmalz as they perform maintenance work under the stands.

It looks like Lt. Ron Polite will not be very busy as a security officer on this day in 1974 with all these empty box seats and only a few people in the grandstand. An Andy Frain usher also surveys the scene of what could be a very peaceful day for both of them. Hopefully a lot more fans will come before game time to root the Cubs to victory.

Pictured on September 9, 1976, is Pauline Mroska at her parking lot on Waveland Avenue, just northwest of Wrigley Field. Behind her is the famous Chicago firehouse (Engine 78) long associated with Cubs baseball. Vendors and ushers would park several blocks away to avoid paying that steep $3.25 parking fee.

Officer Rich Rojewski is on duty at the left field gate along Waveland Avenue in May 1976. A young boy (left) is looking into Wrigley Field through an opening in the gate to see what is happening. Fans watched through holes in the right field fence too, as well as from rooftops across the street, which became big business a decade later.

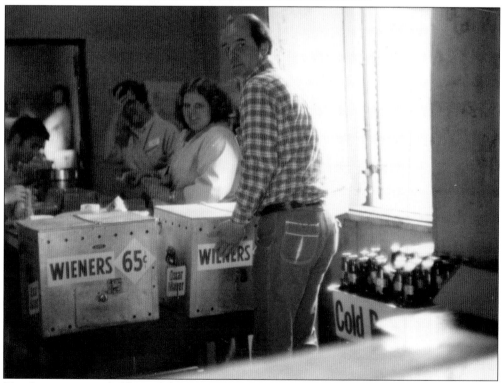

Hot dog containers held 30 of these "meals on a bun," making a load worth $19.50. A vendor would pay that amount to the cashier for a merchandise/commission ticket he would then give to the commissary worker who was passing out the loads. The commissary worker would then return the commission half back to the seller. Vendors had to have a safe place to keep those tickets while they worked because their pay depended on it.

Soda pop and popcorn made the perfect ballpark snack in 1970. Darryl Temkin (left), wearing a *Chicago Daily News* apron, reminds everyone that truly this was "the way we were" because that great newspaper would publish its last edition just eight years later. Mike Rubin (right), however, dreams of "the way it will be" as later in his vending career he would graduate to become a union official. (Courtesy of Fred Homer.)

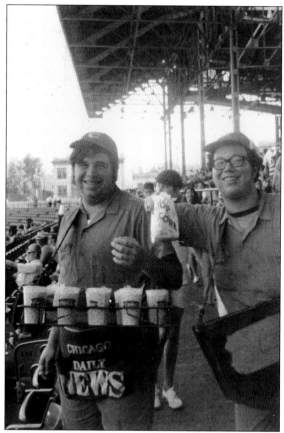

Modeling the new blue and white uniforms of 1987 is Pat Halloran (left) before taking out his first case of beer. Alongside him is the well-respected upper deck union steward Phil Grossman. Grossman was in his seventh decade of ballpark employment, which he began as a 12-year-old popcorn vendor at the 1929 World Series between the Cubs and the Philadelphia A's.

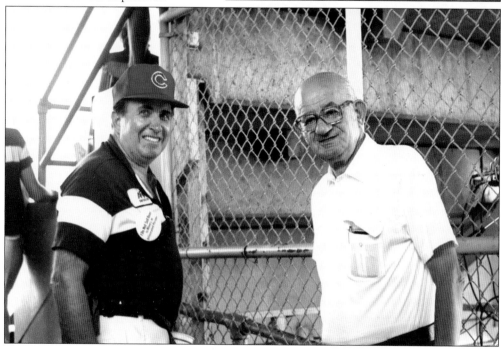

Union steward for vendors was often a thankless job. All the vendors wanted to sell only the best items, and that was not always the same thing depending on the weather. The steward has to fulfill management's wishes to make sure all of the concession items are sold, not just the popular ones, meaning he could not keep everybody happy. Luke Bajic (above), who joined the union in 1953, had that job at Wrigley throughout the 1970s; here he paces in front of his item assignments office. His successor in 1982 was Vince Pesha (below, left). In 1976, Pesha was Bajic's assistant steward, making the rounds to ensure that the vendors' needs were addressed and being counseled by John Studnicka Sr., steward at Comiskey Park. Pesha was elected union president in 1995.

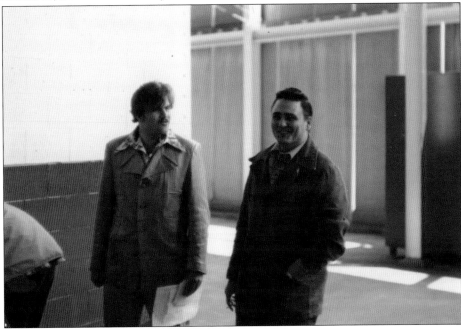

Four

THE LEGENDS

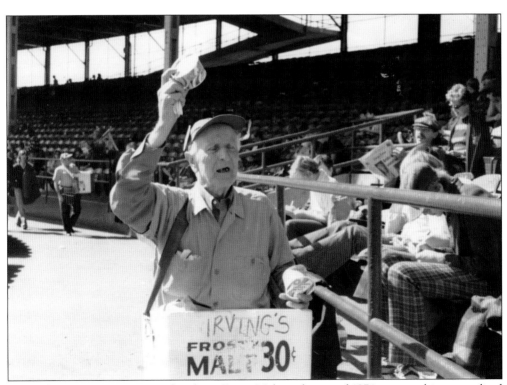

Pictured is Irving "Irv" Newer in his classic Frosty Malt mode around 1974, carrying his personalized "Irving's" box, seen by thousands of Cubs fans during a 40-year vending career. Being legally blind never prevented Irv from putting in a day's work to support his beloved wife, Mae.

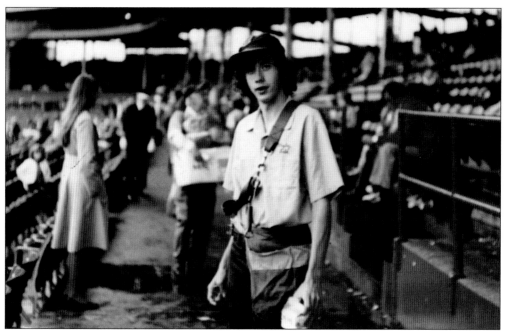

Vendor Wayne Fisher (above in 1975) is unaware that Irv Newer is approaching behind him carrying a double load of Frosty Malts. Cubs fans were wonderful with Irv. They would help him count out their own change since Irv could not tell the difference between the paper bills. No one ever cheated. The photograph below was taken in May 1976. Look at the front of "Uncle Irv's" Frosty Malt container. White mist can be seen coming from the dry ice he is carrying. This picture is most memorable for showing Irv the way he would want Cubs fans to remember him—always smiling, carrying a double load of Frosty Malts, while holding wooden spoons in his right hand and mentoring young vendors like Ross Medow, on his right.

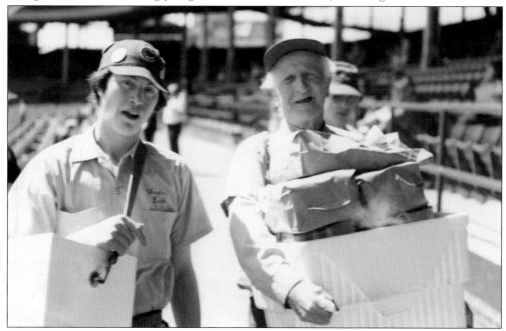

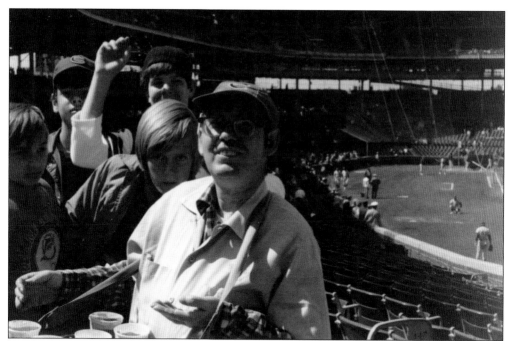

Arnold Gorman was a legend among vendors for being a compassionate and gentle soul who always saw the best in people. He was affectionately nicknamed "The Chipmunk" for unknown reasons. Like the magical Pied Piper of Hamelin, Gorman attracted business from children with his Coke tray and kindred spirit. This chilly day in 1975 (above) finds The Chipmunk in long sleeves to protect against Lake Michigan winds. Children crowd around Gorman to have their picture taken and buy soda from a legend. The photograph below, from May 1976, shows vendors Arnold Lipski (left, holding a beer opener) and Paul Pechter. Six rows up on the left is Gorman eating lunch with Mitch Levin. Even legends must eat.

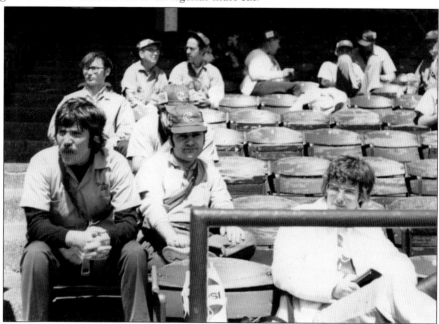

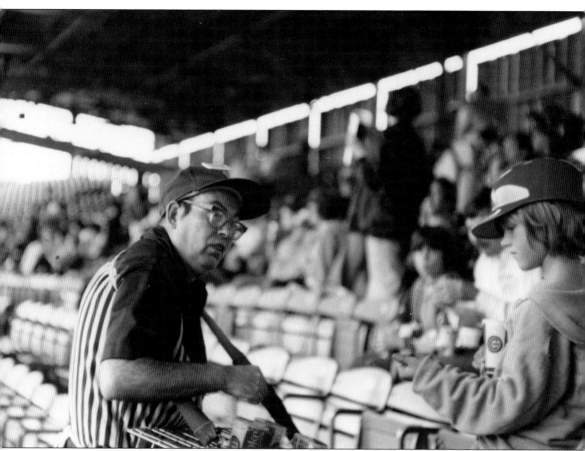

This photograph from May 1979 shows The Chipmunk in action. Gorman has sold a Coke to a young Cubs fan whose left arm is outstretched after just receiving his change. Note that the tray is tilted downward and the Cokes look as if they might fall out. (They did not.) The impish Gorman and Coke and kids were "on the menu" at Wrigley Field for many years. He worked well into the 1980s, living with his mother and brother on Chicago's north side. When his mother died, Gorman was too heartbroken to continue. Mitch Levin visited him one last time in the hospital to recall all the good times they shared under the stands and in the aisles of Wrigley Field.

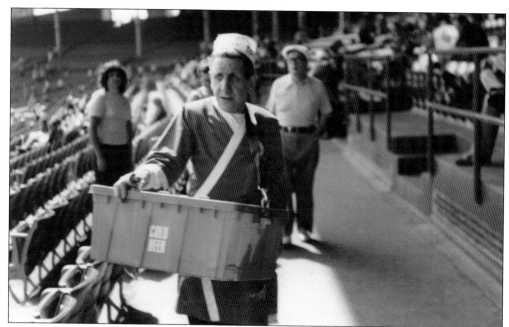

Martin "Marty Mo" Moshinsky was short in stature at five feet, two inches, but long in service as a vendor, working 66 years, at every Chicago sports arena. The above photograph was taken in 1980; he is selling beer wearing the infamous red bathrobe uniform of that year. Below, on August 8, 1988, the first scheduled night game in Wrigley Field history, Marty Mo is selling $5 commemorative programs on the main concourse. With his signature phrase "I don't worry about nuttin," he was a legendary character straight out of *Guys and Dolls*. Opinionated? Gambler (horses)? Cigars? Disheveled? Goofy? Lovable? Incorrect speech? Hot tempered? Intelligent? Gone too soon? All of the answers to this final exam about Marty Mo are yes! (Below, courtesy of Michael Ginsburg.)

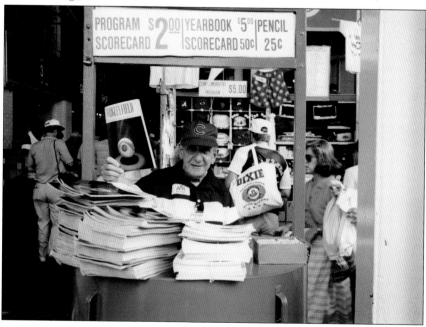

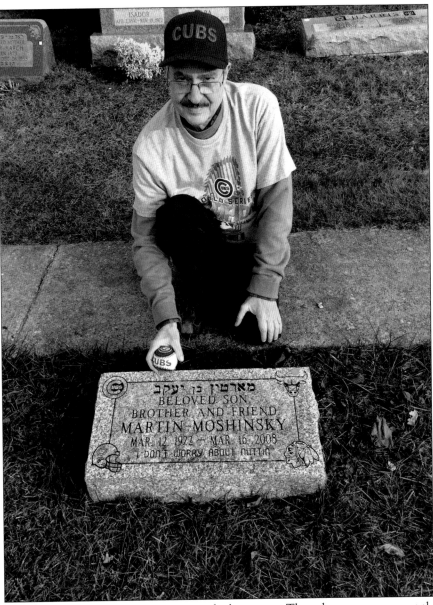

Vendors are competitors. They compete to get the best items. Then they compete to get the most sales. All that changed when Marty Mo died. Cooperation now replaced competition, for this legend had died penniless but not friendless. A concerted effort by Vince Pesha, vice president of Service Employees International Union Local One, insured a proper burial for Marty Mo. Michael Ginsburg collected funds from the vendors and designed a Chicago sports–themed headstone. Chicago Jewish Funerals paid for the burial. The *Chicago Sun-Times* published his story, "Everyone Loved Mo," on March 26, 2008. William Griffin, Michael Ginsburg, Joel Levin, and Mitch Levin were pallbearers. Marty Mo had his proper burial in March 2008, with a service in the summer of 2008. Many vendors attended. Only one final detail remained. On a cold day in November 2017, Joel Levin, accompanied by his wife, Peggy, visited the gravesite of Marty Mo to let him know that he had "nuttin to worry about" indeed—the Cubs had won the World Series in 2016. "Next year" had finally come.

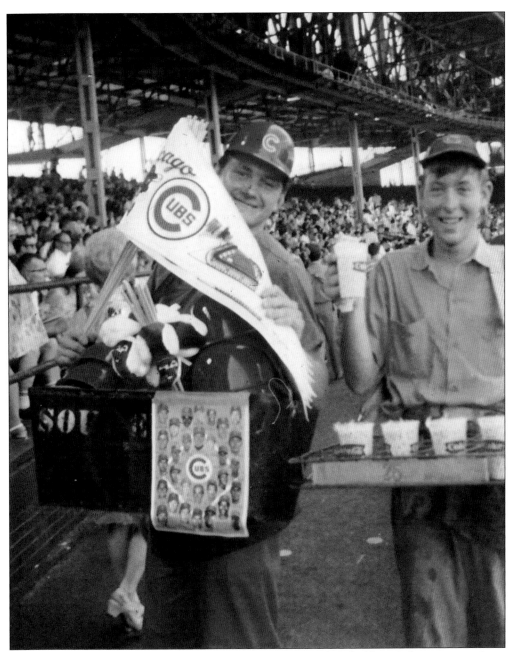

Jim Smith is selling souvenirs out of a large brown basket while holding Cubs pennants. Dave Klemp is selling a tray of drippy Cokes for 25¢. But look closer and much more can be seen in this photograph from 1969. Irving Newer is slowly walking to the bleachers with a double load of Frosty Malts; some "Bums" are waiting for him. The Chipmunk, struggling with a tilted tray of Cokes, has been surrounded by a group of youngsters in the left field grandstand. Marty Mo, carrying a container of hot dogs almost as big as he is, spots The Chipmunk. He decides to sell by Gorman, figuring the kids will buy his hot dogs now that they have their Cokes. (Smart move.) If you look long enough and if you believe strong enough, you will see all the legends of vending, because at Wrigley Field everything is possible. (Courtesy of Fred Homer.)

DISCOVER THOUSANDS OF LOCAL HISTORY BOOKS
FEATURING MILLIONS OF VINTAGE IMAGES

Arcadia Publishing, the leading local history publisher in the United States, is committed to making history accessible and meaningful through publishing books that celebrate and preserve the heritage of America's people and places.

Find more books like this at
www.arcadiapublishing.com

Search for your hometown history, your old stomping grounds, and even your favorite sports team.

Consistent with our mission to preserve history on a local level, this book was printed in South Carolina on American-made paper and manufactured entirely in the United States. Products carrying the accredited Forest Stewardship Council (FSC) label are printed on 100 percent FSC-certified paper.

MADE IN THE USA